LEGENDS AND LOST TREASURE
OF NORTHERN OHIO

LEGENDS AND LOST TREASURE
OF NORTHERN OHIO

WENDY KOILE

Charleston London

THE
History
PRESS

Published by The History Press
Charleston, SC 29403
www.historypress.net

First published 2014

Manufactured in the United States

ISBN 978.1.62619.240.9

Library of Congress CIP data applied for.

For Emma, my daughter. My favorite treasure of all.

CONTENTS

ACKNOWLEDGEMENTS

For several years, I have enjoyed reading books published by The History Press. I never dreamed that one day I would publish, not one, but two books with THP. I would like to give a heartfelt thanks to the THP team, especially my commissioning editor, Greg Dumias. You have all offered support, encouragement and expertise throughout the entire process. Without you, there would be no book.

Secondly, I would like to thank my family and closest friends. Each and every one of you stood by as I worked on my project, helping me through the "I can't do this" days and praising me through the "Gonna write a book" days. Your support is invaluable to me.

Thanks to my aunt Kathy for your enthusiasm and love. You have always been on my "first to know list" about all my life's important events.

A special thanks to my dearest writer friend, Jane Turzillo. Thank you for always being just a text away whenever I needed you. Your friendship kept me going every day!

For all my research resources, I'd like to thank Stephanie at Stark County Library, Genealogical Department; Judy at Stark County Historical Society; Bryon Scarbrough (a giant thanks); Rhonda Cookenour Turner; Louis Foster of Delaware; Jack Wade (favorite islander); hosts Ron and Sharon Rosengarten at House of Rose 'n' Garden Bed-and-Breakfast; Roger Bartley (tour guide and info source); the folks at Minerva Area Historical Society; Henry County Library librarians; the Ashtabula County Library Reference Department; Scott Caputo at Columbus

Metropolitan Library; and many more who offered information or retold the tales.

I would like to thank my family at Zane State College—both colleagues and students. I am so glad to be part of a positive and encouraging work environment. Thank you all for that.

Most of all, I would to thank God for the treasure of life.

INTRODUCTION

We are hunting pirate's gold!" exclaimed my daughter as she and my nephew vigorously worked under our old maple tree. In the recesses of my mind, I knew that digging a hole of such volume was probably not considered neat and tidy landscaping in our front yard. Yet I happily stood by while they worked. It was not that long ago when I had surveyed for treasure in my parents' backyard with much the same passion.

As this book idea took shape in my mind, I pondered the concept of buried or lost treasure. Was it really possible in Ohio? After all, we are not an "out west" territory where outlaws rode off leaving hoards of gold buried in secret caves. Nor are we a coastal state, where pirates came ashore to bury their loot from recent plundering. Thus, what I knew about traditional tales of buried treasure suggested that Ohio was not a prime location for such legends.

However, I could not let the idea go. And then it hit me. It's not so much about actually finding a trunk of gold—although that would certainly brighten my day a bit. Rather, the concept of the story, of how the treasure legends came to be in the first place, is the real treasure. And I have found that Ohioans, especially those of olden days, were not to be left out of such tales. Midwest farming state or not, we Ohioans do love a great local treasure tale when we hear one.

With this new idea in place, I began my research. What I have found is that almost every Ohio treasure tale started from truth and then grew into legend. Whether born from a bank robbery gone bad or a secretly rich

hermit scurrying about, these characters of buried treasure tales did exist. If they left treasures hidden in secret locations, they are yet to be discovered for most of these tales. In the meantime, I propose we enjoy the intriguing life stories that have caused curious Ohioans so much speculation.

As my daughter and nephew continued their quest that afternoon, logic never did sink in. It didn't matter that pirates did not frequent our small town. As they continued the dig, they discussed the pirates and why they hid their treasure in our yard. It was a plausible dream to them. And the thrill was all in the tale, the possibility and, of course, the dirt.

Note: Unfortunately, the children did not find gold. However, they were delighted to find a "dinosaur tooth" that mysteriously resembled a small pebble.

TELLING TALES

I n the first nonfiction book written concerning lost treasure, Ralph Paine states that the "dullest of imagination is apt to be kindled by any plausible dream of finding their treasure." Paine wrote his book at a time when much of the world was "kindled" by tales of treasure. The book *Treasure Island* by Robert Louis Stevenson had been released twenty-five years earlier and had grown to be an international bestseller.

Although written as a children's book, *Treasure Island* was consumed by children and adults alike. To this day, the book remains one of the most beloved adventure stories of all time. Stevenson wrote that "for if he has never been on a quest for buried treasure, it can be demonstrated that he has never been a child." The author capitalized on the notion that the common man—his reader—has most assuredly pondered the thrill of finding a lost treasure. Likewise, Mark Twain states that "there comes a time in every rightly constructed boy's life, when he has a raging desire to go somewhere and dig buried treasure."

In almost every culture, there exist tales of lost treasure. From the Australian Alps to the backwoods of West Virginia, secrets have been handed down for centuries. Patrick Mullen, folklore researcher, suggests that the tales themselves are symbolic of the American work ethic. He states that the "fact that the legends are open-ended—they do not end like some legends do—may indicate that they are standing invitations to Americans to dig and provide their own happy ending to the story."

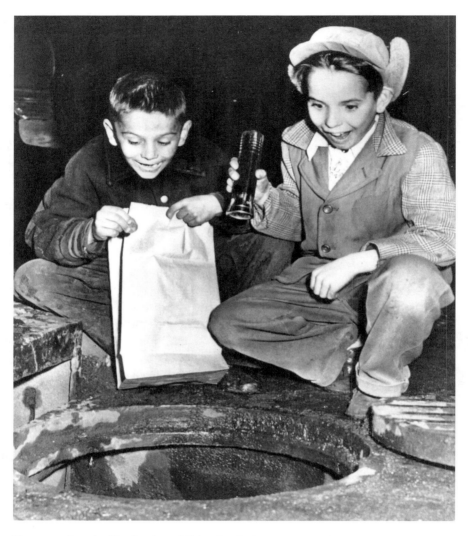

Two young boys in Cleveland are delighted to find several coins after chasing a ball down the manhole. *Author's collection.*

Most treasure tales are presented as just that—tales. However, with every tale, there is always an abundance of fact. The existence of treasure handlers, the historical context and even the wealth can be proved in almost every instance. Yet for some, an actual treasure would need to be dug up to prove its existence. For others, the facts leading up to the secret are enough. The love of a mystery, the thrill of the hunt and great

imagination have kept most tales in circulation. Paine states that "there are no conscious liars among the tellers of treasure tales. The spell is upon them. They believe their own yarns, and they prove their faith by back-breaking works with pick and shovel." Thus, the treasures, and their hunters, continue in the quest.

OHIO'S TALES

As for Ohio, in particular the northern section, the setting may not seem ideal for a good treasure tale. However, by taking a glance at basic Ohio history, one will find a state that presents many opportunities for a great hunt.

Ohio was a territory continually fought over and upon. In the early 1700s, Native Americans, French, British and colonists all sought a piece of the pie. With all the foot traffic through the state in the early years came an abundance of valuables. Thankfully, Ohio granted myriad perfect hiding places. From vast forests and murky swamps to soft farmland, the Buckeye State was a treasure hider's dream.

In the 1800s, war continued, but settlers still made their way into the land of promise. The early pioneers brought their entire life's savings and invested it into the land. Thus, to lose any or all of it was considered a life or death situation. Keeping money and other valuables safe was critical to all early settlers.

During the late 1800s, when things had settled down a bit, Ohio experienced a surge in wealth. A forerunner in canal construction—and later, railroad—travel and trade became easier. This worked well for the emerging industrial state. Commerce and trade were at a high. Thus, money was flowing fairly quickly through the state.

Unfortunately, a modern-day trusted banking system did not emerge until the mid-twentieth century. Banking system failures and counterfeiting were frequent in the early years. With the onset of the Great Depression, the mistrust increased. Thus, places of safekeeping were necessary.

ELEMENTS OF A TREASURE TALE

Structure

In 1951, Gerald Hurley suggested there are two integral parts to a "good tale." First, a hidden treasure must be established. There needs to be some type of proof of the treasure. This is usually accomplished by noting a historical era and outlining the need for burying the treasure in the first place. Perhaps the treasure was hidden during a war while the enemy was chasing soldiers. By naming the war, the opposing sides and the need to hide a treasure, the story becomes credible.

In other words, the tale needs a rational and logical platform. This seems to be the case in the majority of the Ohio tales included in this book. Each tale is rich in Ohio history and examines how the events affected Ohioans. Most fall in a time period when pioneers were struggling to settle the Ohio frontier. These were times when people were desperate to obtain a penny or to protect one by any means necessary. Thus, burying, hiding, hoarding and stealing seemed logical methods for dealing with one's wealth. These methods set the stage for the two major types of tales found in the Buckeye State.

First, and most popular, are tales of robbers snatching treasure and then hiding it, usually by burying it in a secret place. The plan was to come back for the loot when the coast was clear. Likewise, during war times, opposing sides reportedly robbed the enemy. Soldiers or warring natives would hide the valuables with intentions of recovering them after the battle. Unfortunately, as most tales go, the bandits or soldiers were captured, killed or defeated, leaving the treasure in the hiding place for a lucky person to uncover years later. These tales often grow from an actual robbery or wartime crime. The monetary worth changes over the years, but the basis of the story tends to remain the same: someone steals a treasure and hides it, and for some reason the hider never returns for the loot.

A second major type of Ohio tale is one of hoarding. These tales frequently originate in times before a trusted banking system was in place. Settlers brought everything they had to the new Ohio territory at a time of general unrest. Between the so-called savages here and wars and rumors of wars, there was a great need to hold tightly to one's valuables. By hiding it on or near the property, settlers could keep the family valuables in their possession while keeping them out of sight of the public—in particular, thieves.

This is not to say that today's definition of a hoarder did not exist in our history. Indeed, people throughout United States history were noted

for hoarding-like tendencies. Ohio has a fair share of stories where massive amounts of money were found buried under a hoarder's hoard.

Likewise, the presence of a village hermit was often a focal point for hidden riches. In days when visiting neighbors and town picnics were the greatest source of entertainment, an antisocial-type personality could cause quite the stir. Many times, these eccentrics, as they were coined, were thought to hide mysterious secrets. Thus, their lives of solidarity were only a device to hide those mysteries. In a treasure tale, the hermit was always believed to be hiding immeasurable amounts of wealth in or near the hovel.

A second part to a successful tale, once the treasure has been proved to exist, is the hunt. Unfortunately, records, maps and recorded message are nonexistent in most Ohio tales. Sure, the rumor of such items is present, but any tangible clue is not. Stevenson has been accredited with the creation of common symbols that to this day appear in most treasure tales. Lending to most fictional treasure stories, readers will find a treasure map with an X, a buried chest and sometimes a one-legged pirate, as included in the beloved *Treasure Island*. Stevenson's scenario does not occur within Ohio folklore. Instead, the hunt is propelled by historical events, local folklore, hearsay and faith. A map, of course, would be handy, but then again, as Hurley points out, in America the essential interest in a tale is not so much the treasure but in the "idea" of the treasure and the thrill of the hunt. Paine likewise

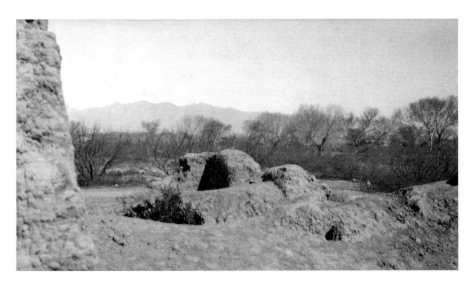

A scene from a supposed treasure location in Arizona. Note the numerous holes in the landscape. *Courtesy of the Library of Congress Digital Collections.*

suggests that the "odds may be a thousand to one he will unearth a solitary doubloon, yet he is lured to undertake the most prodigious exertions by the keen zest of the game itself." Thus, Ohioans need not a map to guide them in a treasure quest.

On the Hunt

Once the treasure is proven and the clues revealed, the actual hunt itself can occur. This is more easily said than done. In fact, Patrick Mullen suggests that the "means by which a person is prevented from finding the treasure makes up the longest and most exciting part of the narrative." Thus, the challenges, enigmas and mysteries of a treasure's location create the best part of the tale.

In some cases, a supernatural element may emerge. Often, a ghost or demon may guard over the treasure. Washington Irving, who was well versed in treasure legends, wrote in "The Devil and Tom Walker," "The devil presided at the hiding of the money…but this is well known, he always does with buried treasure, particularly when it has been ill gotten." Perhaps the eerie conditions under which many search have led to the use of mediums, séances, divining rods, hypnosis and even Ouija boards.

Timing is an important ingredient when hunting for treasure. Many hunters believe that the best chances of retrieving loot are between the hours of midnight and 3:00 a.m. The spirits are believed to be at rest during this three-hour window. A full moon, similarly, is believed to bring good luck on a hunt. Consequently, the nighttime hours work well for other hunting musts: secrecy, trespassing and adventure.

Last but not least, many times treasure tales involve a prequel to the story. This is the part that mentions that a map at one time did exist. Sadly, though, the treasure map has been lost to time, with only a few clues remembered here and there. In the same manner, the burier of the treasure often attempts to give information while on his deathbed. This, too, is prevented from being recorded. Many times, the burier is unable to tell the tale coherently due to his near-death condition.

Ohio treasure lovers have adopted all of these notions as valid concerns while hunting treasure.

THE REAL TREASURE

Storytellers and historians present their listeners with a believable and suspenseful tale that is passed down through generations. The open-minded hearer of the tale is able to connect with the treasure hider on many levels. The desperate need to protect valuables and the fear of losing it all is the basis for most treasure hiding in the first place. On the flip side, greed and mistrust may be at play. Regardless, the receiver of the tale relates to the fear and often maddening decision-making experiences of a past fellow Ohioan.

Likewise, the determined need to find a treasure is comprehensible as well. Many seekers will go through any obstacle to find one. This desire to acquire wealth through hard work was, and is, a core belief for Americans throughout the country's existence. Treasure hunters exhibit a fierce passion and persistence that is actually quite inspiring. With enough hard work, anything is possible.

Like early treasure tale researchers learned, perhaps it's not the treasure itself that fascinates but instead the treasure story and all it uncovers about past, as well as present, generations.

WAR AND PIECES OF GOLD

In war, truth is the first casualty.
—Aeschylus

GOLDEN CLUES, MINERVA

In all the treasure tales known in the state of Ohio, the most believed and most searched for is the "Lost French Gold of Minerva." This tale takes its place in Ohio history not so much for its monetary value, although the alleged $4 million treasure would make for a decent shopping day, but rather for the clues as to its whereabouts.

Throughout the entire French and Indian War, both the French and the English wanted territory near modern-day Pittsburgh, where the Allegheny and Monongahela Rivers meet to form the Ohio. This would give them control of the entire Ohio territory. The French army claimed the Pittsburgh area and called it Fort Duquesne. The British believed the area was under their control, as they had originally set up trading posts in the vicinity. The battling over the area raged for several years, with the French holding fast to their spot at "the forks" on the rivers. Twice before, the British had sent troops to attack only to fail against the French. However, the French knew that the attack of 1755 led by General Forbes would not turn out so well.

Thus, the generals made plans to protect the army treasury, supposedly containing gold and silver for payroll and pioneer trade. Ten soldiers and

sixteen packhorses were loaded down with the treasure and told to make haste to Fort Detroit.

If the soldiers had map-quested their route, they would have been instructed to utilize what is known as the Great Trail. This was the primary route to travel from Fort Duquesne to Fort Detroit. The trail was basically a dirt path worn down by Native American tribes prior to the arrival of Europeans. Earlier settlers found the path and drove over the area in wagon trains. The popularity of the trail soon propelled construction of many stagecoach stops and trading posts. But with twists and turns, rough ledges and swampy pockets, the trail was not the paved interstate system of today. Yet this was the only logical choice. Unfortunately, the British were well aware of the same trail and easily tracked the French into Ohio, near present-day Minerva.

Their capture was eminent. Although the ten French soldiers had eluded the British army for nearly three days, they could hear the distant shouts of the encroaching enemy coming from a few miles behind them.

It was time. The Frenchmen knew they were to protect the military gold at all costs. With one soldier keeping guard on the ridge near the trail, several other soldiers made their way down into a steep valley. Quickly, as they could now hear the clip-clop of several horses approaching, the men dug deeply and furiously into the ground, dumping the gold and silver into the hole. With a few minutes to spare, they quickly made a crumb trail of sorts in order to return later to the hidden treasure. Finally, they threw two shovels under a nearby fallen tree and began to ascend the hillside. As they reached the top of the hill near the trail, they watched helplessly as the enemy force barreled around the bend, muskets already drawn.

On that fateful afternoon in 1755, eight French soldiers were shot down in an instant. Two soldiers miraculously escaped. One treasure remained untouched in the dirt. And Ohio's most talked-about treasure tale was born.

The tale unquestionably gained notoriety in 1829. One quiet morning, a stranger rode into Minerva. He claimed that he was the nephew of one of the escaped French soldiers. Apparently, while riffling through his late uncle's papers, he had stumbled upon a letter—a very puzzling letter, to say the least.

The letter describes the oncoming battle at Fort Duquesne, the mad dash to protect the army's gold, the attack at Minerva and, most intriguingly, the clues to the hidden treasure's location. The writer, the stranger's uncle, explains:

We made the following marks of the area before we fled. The gold was buried in the center of a sort of square formed by four springs. About one half mile to the west of the hole in which the treasure was buried, we jammed an old rock into the fork of a tree so that it would stay. Six hundred steps to the North of the hole are the shovels. As we left but the East, I carved a deer into a tree, which I judge to be one mile from the hole.

The "we" is the stranger's uncle and another soldier by the name of Henry Muselle.

As the mysterious rider of 1829 brought news of this to town, the little village experienced a mini gold rush of its own. Many people knew exactly where the four springs converged, and they certainly were not telling the stranger with the letter, even if he was offering a large reward for information.

The four springs were near a farmhouse tucked down in a valley. Quickly, men, women and children made the trek to the entanglement of springs. The vast farmland soon resembled a slice of Swiss cheese. The owner of the farm, Clayton Robbins, was not left out of the dig. In fact, he was infatuated with the idea of buried treasure on his property. Most likely, Clayton had turned up one of the clues in the quest. Rumor had it that Clayton and his family used two French shovels to stoke their wood burner.

If the treasure was found in those early days of digging, no one stepped up to share. Eventually, the story died

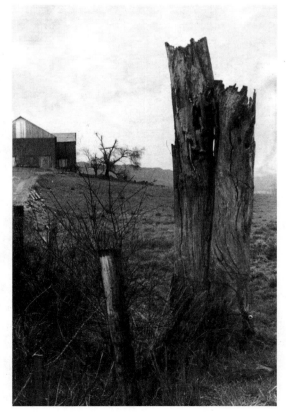

The tree where the odd-shaped rock was found. *Courtesy of the Minerva Area Historical Society—Lost French Gold Files.*

down, only remembered by diehard treasure seekers and young children who frequently played "treasure hunters."

In 1875, the fever struck again when another clue was uncovered. Apparently, a uniquely shaped rock was found in a fork of an old oak tree by T.E. Whitacre, who owned the farm adjacent to Clayton Robbins's. Likewise, a skeleton with a French musket was found nearby.

And so the rush was on again! Shops in town sold divining rods for $100 each. Even a gold-hunting machine, made with whalebone handles, was brought in from New York City for the search. This time, the media joined in, alerting treasure hunters from afar. The story continued in this fashion as other clues were found, including what looked to be a deer head carved into an old tree.

By the 1950s, the puzzle was on the verge of being solved. Four springs—check. Odd-shaped rock in a tree—check. Deer carving—check. Shovels—check. Buried treasure—big red uncheck. So where is it? Every type of search had been conducted. From the performance of midnight séances to the use of dragline equipment, every resource had been used in this quest. One legend even noted that an old Indian chief was boiled and eaten in hopes that the secret would reveal itself. Whether relying on

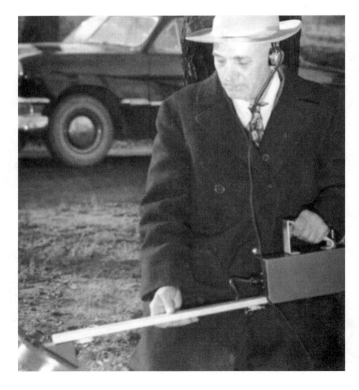

A man with a homemade detector hunting for the lost French gold in 1949. *Courtesy of the Minerva Area Historical Society— Lost French Gold Files.*

faith in the powers that be or high-tech gadgetry, the hunters of the lost French gold have not struck gold to anyone's knowledge.

Perhaps the perils of former treasure hunters have scared some away. For example, Mr. Pim, who worked with Clayton Robbins, reported that he was struck and blinded in one eye while hunting the treasure. This, he believed, was a sign from God. Another man believed he could find the treasure if he was not spoken to on the day of his search. Accepting no nonsense, the wife of the fellow had a few words for him that day. The next day, the man found his horse lying dead in the hole he had dug— lesson learned.

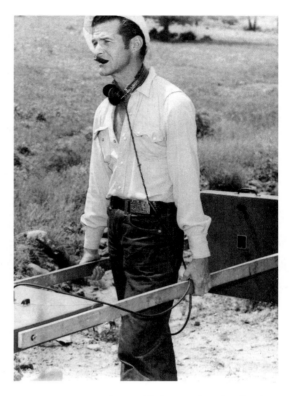

A man with a his "high-tech" detector hunting for the lost French gold in 1949. *Courtesy of the Minerva Area Historical Society—Lost French Gold Files.*

One theory that gained some clout over the years was the notion of the tenth soldier. The letter mentioned that two soldiers had escaped the British that afternoon on the trail. The nephew of one came to town from North Carolina about seventy-five years later. The other soldier, Henry Muselle, was never mentioned again. They were the only two people who knew the exact location of the treasure. Did the tenth solider come back for the gold and silver long before the nephew of his fellow solider?

In the late 1990s, Floyd Robbins, grandson of Clayton, decided to sell the farmland that had been frequented by many treasure seekers. In the deed to the property, Floyd clearly states that if a treasure is ever found, he or his heirs shall receive half. After all, three generations of his family had spent countless hours hunting for the cache.

In his 2003 historical fiction book *Henry Muselle's Treasure*, author and historian Roger Bartley discusses the clues, the geography and current technology that could be used in finding the treasure. Roger believes that it is "very probable that a treasure exists when taking into account all the history." Perhaps with new technology, modern-day storytellers and much faith, the mystery will be solved. Until then, Twilla Carmen, T.E Whitacre's granddaughter, says to "enjoy it, dream of it, and search for it if you can."

DON'T GIVE UP THE SEARCH, SANDUSKY

The defining battle of the War of 1812 came on a brisk fall morning in 1813. At 5:00 a.m., the alarm was sounded at Put-in-Bay. British ships had been spotted just off shore. Commodore Oliver Hazard Perry gave the command to man the ships. The Battle of Lake Erie, lasting only a few hours, gave the Americans control over the lake. This, in turn, led to the eventual defeat of the British.

Over one hundred years later, Reverend John Coup, a resident of the Ohio Soldiers and Sailors Home, thoughtfully gazed out the window toward the bay. As he stroked his gray beard, he pondered that old Battle of Lake

An illustration of Commodore Oliver Hazard Perry during the War of 1812. *Courtesy of the Library of Congress Digital Collections.*

Cottage H of the Sandusky Soldiers and Sailors Home. *Courtesy of Columbus Metropolitan Library Ohio Postcard Collection.*

Erie. Most people at the home loved to talk strategy and how Perry's fleet took down the enemy. But Revered Coup was not contemplating the firing of the cannons or the magnificently built warships. Instead, he was concerned with the behind-the-scenes events in the few weeks prior to the great battle.

Like many of the folks in Cottage H, where he spent most of his day, John was no stranger to war. Fifty-five years earlier, he had enlisted in the Civil War as part of the 164th Ohio Regiment, Company K. After the Civil War, he continued his military career until the turn of the century. As much pride as he took in his extensive service, John's real passion had always been in inventing useful items.

In 1896, for example, John had invented and patented a safety appliance for drawbridges. With a wife and seven children to support, his invention kept them fed and clothed. And if things went well with his current invention, his children, and now grandchildren, would never have to worry about finances again.

In the fifteen years John had lived in the Soldiers Home, he had plenty of time to invent. Likewise, John and most of the other residents had a strong interest in military history. And considering they were located in Sandusky, a couple miles from the bay, the War of 1812 was a hot topic. With his love

for inventing and his knowledge of local history combined, the reverend was ready to test his latest invention.

John Coup was convinced that Perry and his men had buried gold and silver of "inestimable value" on the eastern shores of Sandusky Bay. With the help of a trusted friend, John lifted his ingenious treasure detector onto his shoulders, and the two men set out toward the bay. Under the cover of darkness, the partners worked the shoreline. With John operating his contraption and his partner holding the lantern, the two began to dig.

Bay residents noted the lights near the shoreline. But it was not the first time. For weeks prior to John's excursion, many people had reported "mysterious lights" out on the "big island." Although never confirmed, the townspeople would later assume it was John Coup out on the island searching for treasure.

With the small stir over the nightlights, the local media and eventually big city papers took interest in the story. John claimed he had located the treasure and it was only a matter of time before he surfaced the hoard. He claimed the holdup was the fact that Perry had laid oak planks over and under the treasure as a means of protection. Consequently, the heavy wood was slowing the dig.

Although John Coup never recovered the treasure, he continued to hold firm that there was indeed a treasure buried in Sandusky Bay. Reports still float in from time to time about strange lights in the bay. Perhaps it's the captain coming back for his gold. Or perhaps the reverend never gave up his search.

THE TURKEYFOOT TREASURE, SHUNK

The battle was quick and to the point. Anthony Wayne was here for a purpose: the Indians and all their supporters were to be driven out of Ohio once and for all. At this battle in the midst of downed timbers, the American soldiers had no trouble felling their enemies. By year's end, the Indians agreed to leave the territory they had called home for so long.

Trouble had been brewing for years, and President Washington had had enough of it. Prior to the Battle of Fallen Timbers, his prized army had been thumped by Little Turtle and his tribe. When Washington sent two of his captains to negotiate for peace, both officers were killed. Thus, the president called in the big guns.

"Mad Anthony" Wayne was known to be a force not to be reckoned with. Upon orders to drive the last of the Indians from Ohio, Mad Anthony made preparations for swift defeat. He built a training camp in Kentucky and intensively drilled his soldiers for several years.

As the two sides prepared for an all-out battle, quick territorial fights continued throughout the years. Anthony moved his army up the Miami River, throttling every Indian camp and village it encountered. The Indians attempted several times to overrun the American fort, but to no avail. When the enemy attacked and robbed a supply wagon train less than one thousand feet from Fort Recovery, Wayne decided enough was enough. He was ready for the final battle.

Meanwhile, the Indians sensed retaliation was in the air. They, too, were calling in reinforcements as fast as flying bullets. Soon, the army of Native Americans was two thousand strong. They also chose a perfect location for the inevitable battle. Near the river, tucked into the forest, hundreds of trees had been knocked over by the "great winds," or an F3 tornado in modern terms. The trees would offer perfect cover against oncoming bullets.

Mad Anthony was a strategist himself. He knew the rumors had made it to the Indians that the attack would be coming. Yet Wayne's army showed up fashionably late. See, Wayne had studied the customs of these Indians. He knew that before a great battle, the natives would fast and hold all-night ceremonies to prepare. Thus, he kindly gave them an extra day to do so. The weakened state of the Indians has been blamed for their defeat.

Many of the Native Americans retreated to the area known as the Black Swamp. However, the feuding between the settlers and Indians continued, and the tribes were eventually driven out west. But before their move in the 1830s, one small tribe residing in the now lost town of Shunk decided to bury its possessions.

The village's most prized possession? Bars of gold that belonged to Mad Anthony and his army. That supply train the natives had attacked a few months before the Battle of Fallen Timbers not only supplied the usual army needs but supposedly the army's pay as well. The pay was usually shipped as golden bars, and the higher-ups would press coins out of these. Perhaps that's what lit the fire under Mad Anthony to finish it all.

Now the Indians faced the task of storing their treasure. After careful calculations, it is believed that the gold, along with several valuable belongings, was buried on the banks of Turkeyfoot Creek, opposite the north bend in the wide creek.

The leaders of the tribe drew up a map. The plan was that the Indians would someday reclaim their Ohio territory and anything buried therein. In the meantime, the natives worried about greedy settlers finding their treasure. Thus, the shaman called on a warrior spirit on horseback to guard the spot until the natives could return to claim the hoard.

As years passed, the tales surrounding the treasure were whispered about the tiny towns of Putnam and Henry County. It was rumored that maps to the treasure were cropping up in Oklahoma. Whether or not the rumors were true, a stranger arrived one day in 1926 in the small town of Napoleon. Rumor has it that he asked for directions to Turkeyfoot Creek, where he set up camp. While local men trained their coon dogs at night, the stranger was seen digging along the banks of the creek. When the locals approached the stranger, he blatantly ignored them.

It came to pass one afternoon that townsfolk found the stranger lying in a ditch along Route 109. Upon investigation, they found the man unconscious with no apparent wounds. The town put him up in the Wellington Hotel to recuperate. The next day, the man disappeared and was never seen again.

The story of the stranger is not so strange in and of itself until you take into the account what happened to poor Thurman Dresbach years earlier on his treasure hunt.

The young local boy helped his family on their farm in Shunk. When he wasn't helping his father with chores, he loved to go exploring. One of his favorite places to go was along the Turkeyfoot Creek bed. He took a long iron rod with him in hopes of scaring up a few snakes or turtles hiding in the muddy banks.

What transpired in the woods that afternoon is rather hazy. As Thurman's mother was hanging out the laundry, she heard an ear-piercing, terror-filled scream from the woods. In her heart, she knew that it was Thurman's scream. The Dresbachs and nearby neighbors made their way to the creek, only to find the young boy lying unconscious. Once he came to, he continued to scream in hysterics. Supposedly, he was terrified of a ghost on horseback that had barreled toward him in the woods.

In 1931, a farmer by the name of William Precht was killed in a tractor accident on a bridge spanning Turkeyfoot Creek. No one seems to know what happened to make the thirty-eight-year-old lose control of his tractor. The old farming road on which William was killed leads to a cemetery known as Showman-Edwards Cemetery, and it, like the "Precht" Bridge, is labeled as abandoned. A perfect setting for a treasure/ghost legend.

A scene along Turkeyfoot Creek. *Photo courtesy of Laura Hetrick.*

Whether explorers are hunting Mad Anthony's lost gold or simply seeking a good scare, this is the area to look. Between the Indian Warrior Spirit, Precht's ghost and the forgotten cemetery, one is sure to find something of interest.

GIRTY'S TREASURE ISLAND, NAPOLEON

If one were in desperate need to bury his treasure—say, after a good village raid or two—then Napoleon, Ohio, probably would not be top on the list. However, if you dwelled here and already had a good hideout that had proved itself time and time again, well, perhaps there could be some potentially worthy spots to hide your treasure. Such was the case for Simon Girty, and this is the tale of his island and his treasure.

At an early age, Simon and his brothers were subjected to cruel events that forever changed the course of their lives. Starting with their father,

Simon Sr., who was known for drunken brawls and a mean streak, the boys learned violence early on. During their teen years, their father was killed by an Indian with whom he picked a fight at the local watering hole.

A few years later, Mrs. Girty married a local farmer by the name of John Turner. John was a good man, a hard worker and a caring father to the Girty boys. However, just when things were looking up, another blow to the Girty family occurred.

In 1756, during the attack of Fort Granville, Pennsylvania, the entire Girty family and John Turner were captured by Seneca Indians. Simon was a teenager at the time. All three brothers watched as the Senecas tortured and scalped their stepfather. As the French and Indian War continued, the brothers would look on as new captives met the same fate as John Turner.

Simon and his brothers were divided among the various tribes as rewards for the Granville attack. Simon stayed with the Senecas, the most violent of the tribes. For the next few years, Simon learned the language, customs and beliefs of the tribe. In fact, he was quite intrigued by this way of life and sought all the knowledge he could.

After the close of the war, Simon was released from captivity. For a few years, Simon took up work at Fort Pitt and served as an interpreter between the officers and Indian leaders. When the Revolutionary War geared up, Simon joined with the Americans to fight the British. His goal was to move through the ranks and become a powerful leader in the army. However, when this did not go as planned, Simon became embittered. Thus, he decided to simply switch sides and joined forces with the British at Detroit.

With his newfound place in the world, Simon helped attack his fellow Americans. He was present at the torturous death of Colonel Crawford. Legend says he could have stopped the death, but he reportedly nodded his head to proceed with the colonel's murder.

Simon was considered a traitor and was hated by Americans in general. He was known throughout Ohio as a violent man capable of any kind of evil. It did not help matters that Simon paraded about in Indian garb.

In the 1780s, the brutal war came to an end. Simon moved in with his brother James near Napoleon, Ohio. James had set up a trading post and cabin on the bank of the Maumee River. Perhaps this type of livelihood was too tame for Simon because Simon continued to lead Indian raids in nearby villages. He was held responsible for many of the Indian uprisings in the 1780s. In 1782, there was an $800 reward, provided by the American government, for the head of Simon Girty.

Luckily for Simon, he had the perfect hideout when being pursued. Simon would swim out into the river, land on a small island and hide in the primeval wilderness. According to the book *The History of the Girtys*, "The island when viewed from the shore it would seem that neither bird nor beast could penetrate the tangled and interwoven masses of trees, shrubs, and vines which are nurtured by its fertile soil."

Not only was Girty rumored to hide himself here, but he also hid much of his loot from his raids on the island. It was believed that he had amassed coins and other valuables during his attacks. Likewise, legend states that Simon sunk one of Anthony Wayne's cannons from the shore of the island. Thus, a tale of buried and sunken treasure circulates among treasure seekers to this day.

In the 1790s, Girty fell from favor with the Indians. They held him responsible for their defeat at the Battle of Falling Timbers. He had encouraged the Indians to fight Mad Anthony Wayne and his forces. When things did not turn out so well, the Native Americans were furious with Girty.

Girty's island hideout was no longer adequate with both the Indians and Americans hot on his trail. Thus, Simon sought refuge in Canada. He was never permitted return to the United States after that. As an old man, he was crippled with rheumatism and completely blind. He passed away in 1816.

The remains of the Girty cabin were discovered by early farmers in the 1820s. The island was visited occasionally as a fishing spot for the settlers but was virtually left to nature. In the 1830s, several underwater specialists came to the Maumee River to search for the cannon. However, nothing was found.

In the early 1900s, the Voight brothers received ownership of the island. They noticed the fishermen, swimmers and family picnickers who frequented the little island. The brothers soon opened a ferry service to ship people to the middle of the river. Once this proved successful, the brothers capitalized on the island even further and began clearing the land for a grand project.

Before long, the island was a favorite tourist attraction. Sandy beaches, playgrounds, picnic areas, campgrounds and even a dance hall and bowling alley were part of the fun at Girty's Island. Steamboats were active on the river in these days and brought many tourists to the island. Likewise, the town of Napoleon was growing as well, and the playground offered a nice retreat for the early farmers and shopkeepers.

Unfortunately, the island was frequently flooded, causing damage to many of the buildings. A few years after the Great Flood of 1913, the brothers called it quits, and the beloved Girty's Island attraction closed. For years, people still continued to camp, swim and picnic on the island.

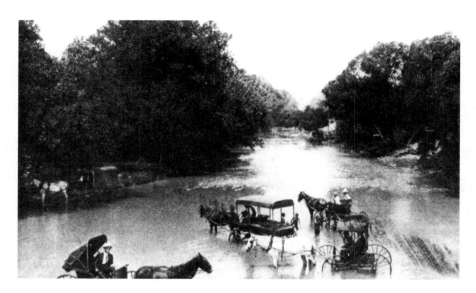

A scene showing early pioneers forging the Maumee River to Girty's Island. *Courtesy of Henry County Historical Society.*

Nowadays, the island has replenished itself with trees and wildlife. Canoers and kayakers visit the island for a quick break or a hike. Only a few remember the days of Girty's Island Park. And fewer yet know of the tale of Simon Girty and his treasure island.

Chapter 3
CRIMES: STASH AND DASH

"Who hides it?"
"Why, robbers, of course—who'd you reckon? Sunday-school superintendents?"
—The Adventures of Tom Sawyer, *Mark Twain*

FLOATING FUGITIVES, FAIRPORT

The three figures set hunkered in the small boat. They were exhausted. Bank robbery, especially in another country, was not easy. The trip across Lake Erie to Ontario was bad enough. Throw in a gold heist, a mad dash back to the shore and now a sixty-mile trip back across, and anyone would be near collapse. However, this little boating trip had been well worth the exertion. Loaded down in the bottom of the small vessel was gold—pounds and pounds of it. Not bad for a day's work. Not bad at all.

The robbery itself had been quite easy. In 1862, there was no such thing as PIR motion sensors like in today's banks. And the Royal Canadian Mounted Police—well, it would be awhile before they showed. The three thieves stealthily scuttled back down the shoreline and into their boat without much drama at all.

The ride across the lake was nerve-wracking, to say the least. But it was now nearing an end. As the three watched the circular pattern from the Fairport Harbor Lighthouse beacon, they knew they would simply follow it to shore and land the vessel with its precious cargo.

As they approached the shore, the men guided the boat into the harbor. Working against the current, and using the last of their strength, they paddled

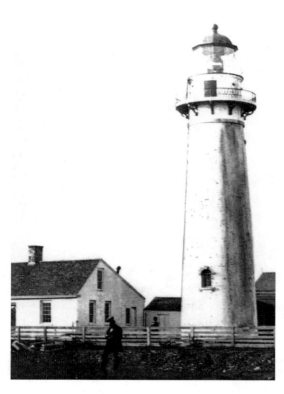

The first Fairport Harbor Light. *Author's collection.*

into the wide Grand River, which empties into the lake. About two miles in, they finally felt safe enough to land on the west bank.

After a few minutes' rest, and with the blue cast of daybreak settling in, the men got to the most important task of the night: divvying up the loot. Although they had worked as a team through the entire project, a snag in the plans began to emerge. The three robbers started to argue among themselves. Although there was nearly $50,000 in gold, each man complained about his cut in the profits.

The strongest of the three eventually overtook the other two and killed both of his partners. He then proceeded to bury the bodies and the loot on the riverbank, keeping two bullion bars for himself. He marked off the paces to the treasure and quickly hightailed it out of the area. His intention was, of course, to come back for his prize once the coast was clear.

Unfortunately, robber number three was unable to make a return trip to Ohio. As he lay dying in a Chicago hospital from pulmonary disease six months after the heist, he confessed the entire incident to his nurse and doctor. He explained that the gold was three feet deep, twenty paces northwest of a huge oak tree on the west bank of the river, approximately two miles upstream from the mouth.

The good doctor and a team arrived by steamboat and searched for the treasure, but to no avail. The next year, the doctor sent a team of professionals to Fairport Harbor on a quest for the gold. This, too, proved unfruitful but caused the story to spread across the area.

A peaceful scene along the Grand River in Painesville. *Author's collection.*

Between the years 1863 and 1910, treasure hunters descended on the riverside. Near every oak tree along the west bank within a few miles of the mouth of the river the ground was searched, dug and hacked up. Sailors were known to leave their ships and search in the moonlight. One local recalls that as a boy, he enjoyed hunting the treasure or simply watching the lanterns through the trees as grown men did so.

In 1890, a body was found on the banks of the Grand River. The coroner reported the skeleton had a huge hole in the skull, suggesting he was killed by a heavy object striking his head. The body was never identified. A second corpse was never found, yet many believe that the mystery skeleton was indeed one of the original robbers.

One particular problem with locating the treasure for certain is the fact the Grand River has changed its course several times, sometimes naturally and sometimes by man's design. The river twists and turns through the town of Grand River, the harbor area, Painesville and on for another one hundred miles or so. Two miles along the river in 1862 is quite different than two miles along the river today.

If the treasure were found today, it would be worth nearly $800,000.

A FAMILY TREASURY, BOSTON

Maybe when Jim Brown was struck by lightning, he should have taken it as a warning from the heavens. But Jim, with his flamboyant personality, after waking from his three-day coma, saw the incident as one more chance to brag. Not only was he above the three hundred kilovolts of electricity delivered by the lightning, but apparently he was above the law as well. Jim's, and later his son's, lucrative career in counterfeiting money was and is legendary throughout the United States.

Born of a hardworking father and kind mother, Jim and his brother, Daniel, were taught at an early age the difference between wrong and right. They were also taught the idea of hard work and perseverance. So when their father, Henry, passed away in 1802, at the ripe old age of 104, the brothers had learned many of the characteristics necessary to make them honest men.

What went wrong, and exactly when it went wrong, no one is quite sure. Beginning around the time of the opening of the Ohio Canal in 1828, the brothers sought opportunity to use their inbred qualities of hard work and perseverance for "operations as profitable as they were illegal," as Thomas Knight writes in an early article about the family. By the time the locks of the canal were in full operation, so, too, was Jim and Dan's counterfeiting business. With a crew of seven and headquarters secured at the tavern in Boston, the brothers were now ready to utilize their skills.

It is important to note the state of the United States banking system in its earlier years. Between the years of 1832 and 1864, state governments were to oversee banking operations within their states. In the years prior, from 1791 to 1832, the federal system had collapsed twice. After the second failure, the United States government was ready to delegate some power, and some responsibility, to state governments.

For a while, the new state-controlled banks seemed like a good idea. The problem, however, came not so much in the daily operations of the bank but in the currency itself. Each bank was commissioned to mint its own cash. The bills and coins, in turn, were to be backed by a reserve of gold and silver. Thus, if a bank found itself in hardship, it could cash in some of its currency for the precious metal. This system was successful for a time.

In the late 1850s, however, banking overseers realized that nearly ten thousand types of currencies circulated throughout the country. Thus, many banks, when attempting to cash in for gold and silver, found themselves with a real problem. Many bills were found to be worthless. Numerous

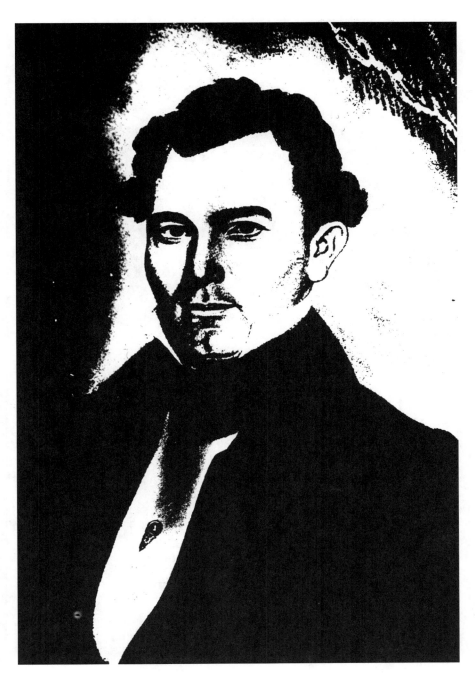

A portrait of Jim Brown. *Courtesy of the Jane Turzillo Collection.*

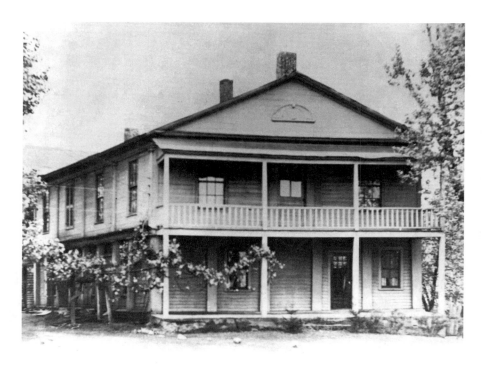

The tavern in Boston used as headquarters for Jim Brown and his co-conspirators. *Courtesy of the Jane Turzillo Collection.*

unauthorized individuals took it upon themselves to create or copy their own coins and bills. In fact, by 1860, according to the comptroller, "counterfeiting was an epidemic."

So when the Ohio Canal was built through the hills of Akron, Jim Brown and his brother Dan were well stocked in knock-off bills. For years, the gentlemen and their cronies had created and then passed the bills throughout the country, always being careful to launder away from their hometown of Boston. And for years, law enforcement and banking investigators were aware of the scheme but were unable to catch Jim and his gang in the act. That is, until the counterfeiters crossed the wrong person in a routine con job.

Apparently, one of the gang members transacted some business with a hog and sheep drover named George Farr, who did business along the Ohio Canal. While at a stop in the Cuyahoga Valley, George sold some stock to a man who produced cash money for the purchase of some livestock. Apparently, when George went to deposit the large amount of currency, he

was told that it was bogus. With his temper in check, George vowed not to get mad but to get even.

George worked his way into the counterfeiters' secret society, where he gained the trust of the gang. Later, George would testify that his "induction into Brown's inner circle required an oath of secrecy that bound candidates to murder any member who revealed the company's secrets." Too bad for Brown that Georege Farr was more than happy to reveal company secret, for in 1826, Jim Brown and several of the gang were arrested on counterfeiting charges. Although Jim and his colleagues were jailed only a short time, they were now under the microscope of the law.

The arrest, however, was not much of a deterrent for Jim and his gang. Even with his young son Daniel playing about the shop, Jim continued his lucrative life's work. It was not until 1831, after his biggest proposed scheme ever, that Jim slowed down.

Apparently, the boys were ready to go global with their operations. They had purchased a large clipper ship, which they docked at a harbor in New Orleans. The plan was to sail the world to purchase foreign teas, spices and silks to sell in America. The ship was loaded down with money, hand-crafted of course, and all the tools needed to produce more money throughout the sailing voyage. The crew men, honest as they were, even obtained proper paperwork in order to sail the vessel throughout the seas. The night before departure, Jim and his business partner, Bill Taylor, sought one last party on shore.

The men visited the many establishments along the streets of New Orleans. The more they drank, the more they threw their money around. This, in turn, alerted the local police. Thus, when the fellows returned to their clipper, the law was close behind. As the officials searched the ship, they did not find evidence of piracy as they had originally predicted. Instead, they found moneymaking machinery, along with approximately $2 million in counterfeit currency. Jim and his buddies were arrested at once.

Bill Taylor was convicted after his dear friend Jim turned state's evidence against him. Daniel Brown, Jim's brother, was convicted and imprisoned; he would die in prison before his sentence was up. Jim, on the other hand, eventually had his case overturned and returned to Ohio. However, his days of being a slick con man were over.

Perhaps it was his constant drinking or the law breathing down his neck, but Jim found himself in and out of prison for the remainder of his life. His wife, Lucy, divorced him, taking their children with her. In 1865, in a freak accident much like the lightening strike, Jim fell from a canalboat and

A portrait of Lucy Brown. *Courtesy of the Jane Turzillo Collection.*

was killed. Nonetheless, Jim's legacy lived on. For it is Daniel, Jim's son, on whom the Boston treasure legend centers.

Daniel, who learned from the best, continued in his father's footsteps. During the California gold rush of the 1850s, Daniel traveled out west to aid the tired souls of the gold diggers. While in the mining towns, Daniel offered

his kind assistance. For the exchange of some genuine gold nuggets or powder, Daniel traded the miners some freshly printed cash. This exchange benefited the miners, who were tired of hauling the heavy metal to the banks and waiting in long lines.

After passing between $80,000 and $100,000 worth of counterfeits, Daniel's operation began to crumble. Miners, bankers and the law were on to his schemes. Quickly, Daniel took the first boat out of the harbor. After traveling in and out of ports, sometimes hiding in jungles in South America, Daniel finally made it to New York. When he debarked from the ship, he was burning up with a fever he had contracted during his voyage.

Daniel made it back to the Brown homestead in Boston. Here, he died of scurvy in January 1851 while the law closed in on him. When detectives learned of his passing, they demanded proof. After all, this was one of America's most successful con artists. The casket was disinterred, and a detective arrived to inspect the corpse. Stephen Mihn writes in his book *A Nation of Counterfeiters: Capitalists, Con Men and the Making of the United States* that the "cavernous remains therein reposing was enough to convince the final skeptic and Brown was buried once more."

The treasure tale, thus, picks up steam at Daniel's death. Detectives were able to recover $20,000 during their search of the premises. However, between Jim's schemes and Daniel's con job out west, officials believed there could be upward of $200,000 stashed on or near the property. This belief was further strengthened the following year.

Two girls playing near Yellow Creek, which ran adjacent to the Brown homestead, found a rusty tin can. As they worked the lid off, nearly $2,500 worth of bills and coins fell to the ground. It was later determined that the bills were counterfeit and most definitely the handiwork of a Brown. The finding proved that the Browns had indeed stashed their loot about the premises.

For years to come, people looked for the lost treasure hidden by the Browns. A few strange occurrences in connection to the treasure occurred. In one tale, Walter Tesmer, who owned property near the Brown homestead, became quite suspicious of his sister, Mary. Apparently, Mary took to the habit of butchering and cooking up the farm chickens on a daily basis. When confronted by Walter, she confessed her reasoning: the chickens had gold dust in their intestines. For weeks following, Walter prohibited the killing of any chickens. Instead, he followed the flock around in hopes of finding their golden buffet. Sadly, the chickens were not sharing that information, and Walter never found the gold.

The Brown homestead sits vacant but well maintained in current years. *Author's collection.*

Likewise, a curious incident occurred at the Bonkowski farm just over the hill from the Browns' former homestead. As Stanley Bonkowski was digging a basement under his farmhouse, he found a wooden box measuring eighteen inches square by four feet long. The box contained a bronze hatchet, an inkpot and a small American flag. Most interesting, however, was the paper at the bottom of the box. The note instructed the finder to "dig four feet more."

Neighbors encouraged Stanley to dig, but he hesitated. He stated that he needed to get to his supper. When the neighbors returned in the morning, they found the hole had been filled in with cement. Stanley stated that he feared additional digging would weaken the foundation of his house.

The Brown homestead and barn are still standing on a hill in the middle of Cuyahoga Valley National Park. Naturally, ghost sightings have been reported near the place. Perhaps Jim, who withstood lightning over one hundred years ago, is keeping a watchful eye on his house and his treasure.

A HANDSOME HEIST, LEIPSIC

Abraham Lincoln once said that "whatever you are, be a good one." Evidently, the infamous gangster John Dillinger understood this concept. For John once explained to the world, "All my life I wanted to be a bank robber. Carry a gun and wear a mask. Now that it's happened I guess I'm just about the best bank robber they ever had. And I sure am happy." As far as bank robbing goes, John and his gang are credited with many successful heists. With so many robberies under their belts, it became imperative to find a place for the safekeeping of their hard-earned wealth. Since depositing it in a bank was not an option, the gang is believed to have stashed the money where it possibly remains to this day.

The beginnings of this treasure story take place between the walls of the Indiana State Reformatory in 1924. On his first real heist, John and his partner were busted on the charges of armed robbery at a small grocery store. John was convicted and given ten to twenty years. Always a likeable fellow, John quickly made friends with some of the more hardened and experienced criminals in the jail. Most of the Harry Peirpont gang was locked up at this time. The Pierpont gang was known as a group of successful bank robbers. In turn, John sought to become acquainted with such admirable characters. While serving time, he not only bonded with other criminals but also picked up many useful tips.

In 1933, John was released from prison to visit his dying stepmother. By the time he arrived home, John's stepmother was already gone. After a few weeks' mourning, however, John did not return to the prison. Instead, he set to robbing a bank in New Carlisle, Ohio. He obtained $10,800 for his first job. For the next couple months, John continued on his crime spree and perfected his skills as he went. Unfortunately, he was not as slick as he thought. John was arrested and held in the jail at Lima, Ohio.

About this same time, Harry Pierpont and his boys were busy escaping from the Indian State Reformatory. Using guns and weapons that their dear friend John Dillinger had smuggled in, the gang overtook the guards and busted out. They immediately traveled to Lima to spring John from his imprisonment in the Allen County Jail. During the breakout, Pierpont fired his gun and killed the sheriff on duty. John Dillinger was set free.

Over the next couple years, John Dillinger and Harry Pierpont partnered to form the most feared bank robbing gang in the Midwest. Robbing banks in Ohio and Indiana, the men are believed to have stolen millions of dollars.

The First National Bank in Fostoria—one of the many John Dillinger and his gang visited. *Courtesy of Columbus Metropolitan Library Ohio Postcard Collection.*

When the boys were not busy on a robbery, they would frequently hide out at the Pierpont Farm that Harry's parents rented in Leispic, Ohio. It is believed that the gang placed their loot in suitcases and buried them in the ground somewhere on the seven-acre farm.

In 1934, the FBI began to close in on the gang. Most of the men were rounded up by early 1934. Harry was sentenced to the death penalty. John Dillinger was sent back to Indiana, where he was to stand charges for the death of Officer Willian O'Malley, whom Dillinger had killed during a bank robbery. Before John stood trial, he once again escaped from prison.

While on the run, John invested in plastic surgery in attempts to disguise himself. He also enjoyed time with his female friends and holed up with Ann Sage, operator of a Chicago brothel. Perhaps John should have listened to his own advice. At one point, his words of wisdom to his gang were to "never trust a woman or an automatic weapon." In 1934, Ann Sage, for a $10,000 reward, tipped off the FBI. John was machine gunned down in front of a theater in Chicago.

Around the same time, Harry Pierpont was electrocuted. The Pierpont family moved from the farm in Leispic not long after Harry's death.

In the weeks to follow, people in Leispic reported seeing shiny black cars roll to and from the old Pierpont place. Many believed, including the FBI,

that some of the Dillinger and Pierpont gang members were returning for the hidden treasure. FBI agents were sent to the farm, where they hid in cornfields and kept watch over the land.

The house, barns and sheds have all been torn down. Cornfields stretch as far as the eye can see in the flat Leispic countryside. Not many people come looking for the treasure, if any at all. In keeping with his bank robbing talents, it seems John was good at hiding treasure as well.

SPECIAL DELIVERY, WARREN

Burl Viller's afternoon was pretty much routine. Leave the Warren Post Office at 1:00 p.m., drive to the Erie Railroad Station, pick up mail, leave the station about 2:00 p.m., return to the post office with the new mail and help old Frank sort it until quitting time. Burl rather liked this drill and had it down to the minute. So when a slow-moving, dark green sedan pulled out in front of him on the return trip that April afternoon in 1935, Burl was a bit agitated. It was 2:30 p.m., and he liked to be at the post office by 2:40 and sorting mail by 2:50. At this rate, he would be completely thrown off his schedule. And to make matters worse, the V-8 sedan suddenly stopped in the middle of Pine Street, about a block from the police station. For the first time in eleven years, Burl would not be meeting his estimated time of arrival.

Burl's mail truck was loaded down with four heavy cloth bags. Two of the packages held a total of $72,000 in cash. This was the payroll for the Republic Steel Company. The other two bags contained $53,000 in U.S. securities. So when the sedan in front of the truck stopped suddenly, perhaps the truck's driver should have been a little more concerned. Only when Burl noticed the machine guns held by the two exiting passengers did he realize that this was more than a stalled vehicle.

The two men quickly entered the mail truck and, holding guns to his side, instructed Burl to drive to a dirt road on the outskirts of town. Next, while threatening death, they had Burl pull into an abandoned garage and park. He waited while the two unloaded the bags. Although Burl had a revolver tucked under the seat in case of robbery, he realized it would be no match for the semi-automatics. A few seconds later, the sedan pulled up to the garage, and the three men loaded the car. Burl was forced into the back of his truck, and the outside padlock was snapped into place. The sedan, and the four bags, sped out of sight.

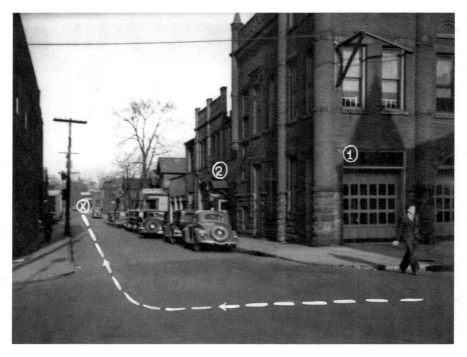

Viller's mail route. The "X" represents where the hijacking occurred. Note the proximity to the police and fire departments, marked with "2" and "1," respectively. *Cleveland Press Collection, CSU Michael Schwartz Library, Special Collections.*

Two girls who had been playing on Franklin Street, which intersects Pine Street, had witnessed the "bad guys with guns" get into the mail truck. Although very young, they knew something was not right with this picture. The girls ran to the police station and reported the incident.

Fairly quickly, the Warren Police found the mail truck and a shaken Burl Villers. He described the bandits and their car. With the description, the police called in for reinforcements, including the federal postal investigators. The search turned up nothing for the first couple days.

On the third day, officials received word that a slashed-up U.S mail bag, dozens of securities and an assortment of registered mail were found floating in Portage Lake. Two young lads saw the bag floating in the lake and rowed out to retrieve it. Two men walking near the North Reservoir of Portage Lake found numerous pieces of unopened mail. Another local teen, after hearing of the find, rowed out to an island a quarter mile from shore and found three packages of bonds on the shoreline. Later, a stack of Liberty Bonds was found on the south end. Calls to the Akron Sherriff's Department poured in that afternoon.

Now the hunt for the robbers centered on the Akron area. Police immediately thought of two of the town's finest, both with rap sheets a mile long. George Sargent and Tony Larrizetti were no strangers to the law. Both had done some time for thievery and various misdemeanors. So when Akron police realized the suspected bandits were most likely stationed in Akron, they immediately looked toward the two men. By the end of the weekend, both Sargent and Larrizetti had been cuffed and sent to Warren.

Interestingly, the two arrestees had no money on them. Their residences, bank accounts and vehicles were scoured with no sign of the missing money. The lake where the bag of mail was found was searched for hours, but divers came up empty-handed. The lost payroll to this day has not been recovered.

During the trial, the two accused men produced solid alibis. Dozens of witnesses testified that the men were nowhere near Warren on the day of the robbery. However, both Sargent and Labrizetti were convicted and sentenced to twenty-five years in prison. The prosecuting attorney fought for the convicts to be shipped to Alcatraz with other hardened criminals. However, both were sent to the Cuyahoga County Jail.

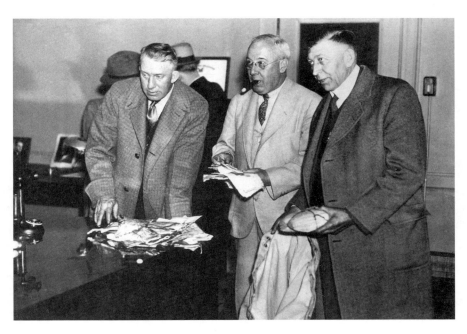

Detectives from Akron and Warren inspect the money found in Portage Lake. *Cleveland Press Collection, CSU Michael Schwartz Library, Special Collections.*

Two years later, evidence surfaced, and the attorney general pleaded the case to President Roosevelt. Evidently, Alvin Karpis, of the infamous Barker gang, and his associates were found guilty of a mail train robbery at Garrettsville, a few miles north of Warren. The train robbery took place six months after the Warren mail robbery. Eventually, it was proved that Karpis and his gang were responsible for the Warren robbery as well. President Roosevelt overturned the verdict on the Sargent and Larizetti trial, and the two men were set free.

The only part of the robbery that remains unsolved is the whereabouts of the missing money. Authorities believed that $72,000 in ones, fives and twenties was heavier than the stacks of letters and securities. Thus, many believed that the money was tossed into the lake during the mad dash from the scene of the crime. The bags full of cash sank to the muddy bottom of Portage Lake.

HERMITS AND HOARDERS

However little he may be attached to the world, he never can wholly forget it, or bear to be wholly forgotten by it.
—Matthew Gregory Lewis

HUDDLESTON'S HOARD, RICHFIELD

At the hushed whispers of her folks, Elizabeth Huddleston crept down the steps to get a better listen. Dad, who had the hearing of a cat, immediately called for Elizabeth to come to the parlor. He instructed the young girl to go about gathering several oyster cans. A few nights later, with her assignment complete, Elizabeth helped her parents pack the cans with gold and silver coins. Dad took the cans and his rusty shovel and headed to the fields. It would be nearly fifty years before Elizabeth learned the whereabouts of those old cans.

The evening air was hot on that spring day in 1888. William Wilkinson, wiping the sweat from his brow, rested under the huge oak tree near the property line. Although he was renting the farmhouse and land surrounding it from Charles Brush, he took great pride in working the fields. He enjoyed the quiet solitude away from the hustle and bustle of Cleveland, a mere six miles north of the farm.

With only a few rows left to plow on this hot day, William ended his short break and pushed the plow through the heavy black soil. Near the end of the far reaches of shade, the plow struck something unusual. William was accustomed to running into a rock or two in these fields; however, this was a

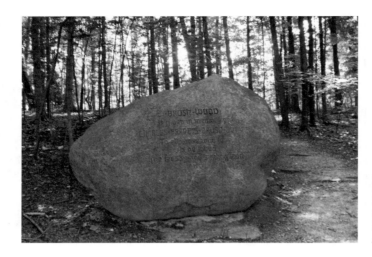

A boulder near a hiking trail in Lake Metro Parks marks the land donated by Charles Brush. *Author's collection.*

different type of noise. As the farmer inspected the ground under the plow, he was delighted to find a huge pile of antique coins. Another few feet and he found yet another cache.

William knew he had found some type of treasure. Knowing that the coins probably belonged to the landlord or a previous owner, William was determined to keep his find secret. However, the coins were so old that William had no idea how much they were worth. Thus, he made several inquiries in town to determine their net value. Soon, the town and the media were abuzz with a treasure tale. The rumor mill was set into motion with much speculation over who hid the money out there on the old Brush farm.

First, some folks suggested that Jim Brown, one of the most successful counterfeiters in the country, hid the coins. The law was always in pursuit of Jim Brown and his son Daniel, and it was possible they needed a place to stash their money. A farmer's field across the hills seemed to be an ideal place for Jim, Daniel or one of their gang to hide their treasure.

Some folks remembered that at one point, an eccentric farmer named Thomas Huddleston owned the farm. Evidently, the farmer and his wife lived in complete poverty. One day, for reasons unknown, the farmer was called away on business in England. When he returned home several weeks later, he was loaded with money. He spent the wealth lavishly on himself, while his wife continued to live in squalor. Before he died, Thomas buried the remains of his mystery money out in the fields, never sharing a penny of it with the missus.

With the rumors circulating about the countryside, William began to fret and hired himself a prominent lawyer. So far, the rumors were farfetched and without much substance. Yet William knew there might come a day

when the mystery was solved and someone would come for the treasure. A few months later, the dreaded day arrived.

The story of the recovered coins had made its way to the area papers, including the *Cleveland Plain Dealer*. So when Miss Elizabeth Huddleston of Cleveland read the story and saw mention of the Huddleston name, she quickly realized that the farm had once belonged to her family. She also knew the real story of the treasure and was about to set it straight.

William Huddleston, Elizabeth's father, had hid the family's wealth during the Civil War days. During a period of unrest, and with John Morgan and his raiders prowling about Ohio, people were not taking any chances. The Huddleston Farm was a thriving business during the war, and the family had plenty of money to lose. Thus, the family's riches were placed into oyster cans and buried in the field.

After the country had settled down and John Morgan was captured, the Huddlestons decided to leave their money in its hiding place. They liked knowing they had cash there to fall back on if such shaky times should arise again. Only the mother and father knew the exact location, and they eventually took the secret to the grave.

Elizabeth, a young woman living in the city Cleveland around the time of the discovery, hired a lawyer. Elizabeth's lawyer contacted William, who refused to discuss the found treasure, referring the questions to his own lawyer. Williams's lawyer did not offer much information but did admit that a large sum of money had been found on the farm. Elizabeth made her way to the Richfield area and began to inquire at the local banks to determine how much money, if any, Wilkinson had deposited. The bankers could not reveal such information, and Elizabeth was sent on her way.

The story caused such excitement that the *New York Times* picked it up and ran a story on it as well. However, the amount of money and the exact location of the hiding spot were never revealed. As for Elizabeth, she never retrieved any of the cash that her father hid so long ago. Likewise, it has never been determined if all the treasure was found.

THE GIFT OF TIME, ASHTABULA

Between 1865 and 1883, Silas Fuller of Ashtabula traveled approximately twenty-seven thousand miles within the Great Lakes region, Canada and Greenland. He was on a mission, and "time" was on his side.

The clock collector, or horologist, had enjoyed his hobby since his youth. As a boy, Silas loved to tear apart the gadgets and see what made them "tick." He would then put them back together and record instructions for doing so. As he reached his teen years, he was hired by locals to repair their watches and other timepieces.

As a young man, Silas became known as a mechanical genius. At eighteen, he invented and patented an apple paring and coring contraption. Cabinetry was another of his specialties, and he was able to sell many pieces as a means of livelihood. He continued to grow his clock repair business, as well, and soon was creating new clocks from pieces and parts of old ones. Soon, he was able to save his money and begin traveling in search of unique clocks.

The fruits of his labor were apparent in 1901 as reporters from the *Cleveland Plain Dealer* arrived for an interview. Word of the collection had spread once Silas began selling the clocks. Nearly two hundred clocks ticked happily throughout the house. Antique pieces dating back one hundred years, ornate foreign timekeepers, rare grandfathers and designer-original clocks lined the walls and the shelves throughout the house. Upon inspection of the backside of each, handwritten instruction was found on how to wind each clock correctly.

A huge clock, compared to the size of a cartwheel, caught many a visitor's eye. This unique item was constructed in Ireland in the 1700s and made its way to America with an Irish family. Eventually, the relic stopped working, and the family had no use for the huge ornament. Thus, Silas was able to score it from the family for a rock-bottom price. He hauled the handsome clock home and, within days, set it to work once again.

The pride of the collection, however, took nearly eight years to complete, for this clock was like no other of its day. Silas built the clock from the parts of others and added his own special gadgets as well. Not only did this tall clock dutifully tell time, but it also displayed the day, month and year. If that weren't impressive enough, this beauty also announced the setting and rising of the sun, the arrival of new seasons and the rotation of the planets and sun. This was unheard of in a world without digital technology.

But like so many other reclusive and eccentric people, tales about the time collector begin to circulate.

First, it was believed that in Silas's later years, he drove himself insane with an idea. Supposedly, the clockmaker had spent years attempting to build a clock that ran on perpetual motion, or motion that is independent of any external force. Thus, in his last few years on earth, he was not technically senile but instead insane due to his obsessive study of machinery and physics.

Secondly, the treasured clock standing off by itself held more than a mechanical secret. It, in fact, held all of the clockmaker's money, amassed over a lifetime. He was pulling the old "hidden in plain sight" trick, as he allowed the newspaper people to photograph and touch his favorite clock. The fact that all the downstairs windows were boarded up only gave the neighbors more proof that ol' Silas was hiding something.

As Silas became less able to care for himself, he moved to Painesville with his daughter. A guardian was appointed over the sale of his collection.

In December 1907, time ran out for Silas Fuller. The clocks, perhaps a hidden treasure and the ingenuity of his life's work are now lost to time as well.

OLD DAN AND HIS DOG, OTTAWA

The howling of the dogs was relentless. For three long days and three lonesome nights, the hounds cried into the fog. One dog, Curly, was especially upset. He was there when his human died.

Dan Shafer, the dogs' owner, commonly known as "Old Dan" in the town of Ottawa, lived in a shack near the old Perry Street Bridge on the edge of the dump. With his five dogs, eight chickens and two ducks, Old Dan was content without much human contact.

Obviously, at some point in his life, he had sought human companionship; he had two deceased wives and two living divorced ones. He also had a grown son, Grant, living in nearby Continental and a daughter living in Alabama. However, the townsfolk knew him only as "Old Dan, the man of mystery."

For years, the nosy neighbors had curiously watched the seventy-something hermit and his five dogs meander into town. While in town, he would stop at the feed mill and market, where he would buy top-grade food and the choicest of meats for his small zoo. He was also known to root around in the huge dump near his shack, pulling tin cans from the debris and placing them in his bag.

One cold Saturday in March 1924, Old Dan was spotted making his usual rounds with his five canine companions wagging along on the trip. As the family made their way to the Second Street railroad crossing, Dan noticed the slow-moving train not far from the crossing. He gave a signal for his dogs to heel. Yet Curly, his favorite of the pets, wandered onto the tracks. He began fervently pawing at a chunk of road kill wedged in the rocks between the rails. As the train blasted its crossing whistle, Old Dan yelled for the dog to return to his side. Curly either did not hear

Left: The Second Street Railroad Crossing in Ottawa. *Author's collection.*

Below: The trail leading to the collapsed Perry Street Bridge that crossed over the Maumee River. Old Dan's shack and the town dump were located along this path. *Author's collection.*

or was more concerned with lunch. With the train only a few feet away now, Old Dan lunged for Curly, shoving the dog off the tracks. At that moment, Old Dan was lifted and thrown several feet from his position by the oncoming engine. Later, it would be determined Dan died from a broken neck sustained during the accident.

Word spread, and for the first time in years, people decided to visit the shack at the edge of town. Rumor had it that the old tin cans plucked from the dump were not just part of a hobby. No, someone as strange as Old Dan surely had a better purpose for his collection. The people were convinced that the hermit used the cans to stash and bury his money. Although no one knew of Dan to work, somehow those dogs ate better than most families in town. Yes, the community was convinced that Dan Shafer hid those money-stuffed cans and even went so far as to periodically unbury the treasure. With his chickens perched about the shack, the mystery man would supposedly count and gloat over his wealth in the deep of the night.

Dan was killed on a Saturday, and by Monday's eve, the shack and small yard leading to the dump were filled with treasure seekers. While some ransacked the house, others dug in the yard.

If some thought Old Dan and his brood strange in life, the man's death was not to prove them wrong. For one, the fat rooster perched on the footboard of the bed apparently tried to communicate with the looters. The old bird mumbled almost human-like phrases. Initially, the hunters assumed the bird was expressing grief, but as night fell in the backwoods, they wondered if the rooster was conversing with the spirit of his master.

To make matters worse, the dogs outside never ceased their mournful song, Curly being the loudest of them all. It appeared that Dan and his pets had a relationship that went beyond the traditional human-animal bond. The creatures seemed to wish to communicate with their deceased beloved master.

As for the treasure seekers, they never found a cent.

Later, it was determined that Dan had $248 sewn into his jacket at the time of his death. This was enough to pay for his burial in nearby Monroe Cemetery.

Dan's son, Grant, attended his father's funeral. He also took the eight chickens and two ducks to his farmstead. As for the dogs, many inquiries were made, and they all found loving homes—the best treasure to give Old Dan and his dogs.

BROTHERLY BONDS, MESOPOTAMIA

The two middle-aged men were brothers, roommates and best friends. John and Jerry Ford had experienced most everything life had to offer. From growing up on a farm to losing both parents, the brothers were bonded together throughout their fifty-plus years. In recent years, they had taken to selling livestock. Their favorite part of the day, however, was the evening spent together sitting near the fireplace. The two would share thoughts on the day's business, as well as retell old family stories. So when the earthly bond was broken by John's death, Jerry was beside himself with grief, as any brother would be. Yet Jerry took his mourning to the extreme and walked away from everything, including the house, property and anything hidden therein.

John Ford had always been the more outgoing of the two brothers. Jerry, on the other hand, was quiet and considered somewhat odd. Nevertheless, the Fords were well liked in the small town of Mesopotamia. The brothers ran a successful farm, mainly selling livestock to area farmers. Between their inheritance from well-to-do parents and their current business, the brothers were quite wealthy.

The homestead was part of the inheritance. Sitting on a hill overlooking the miles of farmland and distant hills, the old stone house showcased the wealth of the family. Built by Hezekiah Halcomb's son in 1815, the structure was unique in its construction. In a recent article, Chris Klingimier states:

> *The stone house sited atop a rise south of Mesopotamia center is a 1½ storey, two room deep center hall house, a common type found in both Pennsylvania and New York. What is uncommon is the quality of the stone and stonework. The façade of the building used stones carefully selected from one strata of the quarry, all exhibiting purple & blue mineral bands. The doorways are exceptional, with dressed stone used for the elements normally rendered in wood.*

The brothers chose to live out their lives in the huge stone structure. Therefore, when John passed away in 1866, the size of the estate exposed the emptiness. Jerry, in his misery, simply locked up the house and never looked back.

For several years, the "old Ford place" sat vacant of human life. Rumors, of course, swirled through the town. Neighbors were certain that the brothers hid money in the house and around the land. Yet no one dared cross the property line, for another rumor strongly suggested the presence of John's

ghost guarding over the house. Accordingly, people kept their distance from the old place.

In 1900, Jerry's niece became intrigued with the home of her ancestors. After talking with her uncle, who seemed indifferent to the idea, she acquired a key. Her mother accompanied the young woman on her trek up the hill.

Once inside, the niece experienced a sort of time warp. Entering the house, everything—all the way down to the dirty pots on the stove—was left exactly as it had been thirty years prior. Lavish furnishings, clothes and newspapers were virtually untouched.

As the niece and her mom rummaged around the house, they stumbled upon a dark wooden chest. Inside, the pair found numerous faded legal documents, including deeds, bank records and medical records. Most interesting, they found a tin can with gold and silver coins totaling $500.

Immediately, the niece reported the findings to her uncle. However, Jerry wanted no part of anything relating to the house. When the niece went back for the tin, she discovered it had been stolen. Evidently, people no longer feared the ghost.

For those who remember the Ford brothers, the legend still tells of buried money on the property. Today, the house is a quaint bed-and-breakfast retreat in the midst of Amish settlements. Guests enjoy quiet evenings and the lovely views from the stone house. So far, no ghost sightings or treasure finds have been reported.

Chapter 5

RICH AND FAMOUS

History is the version of past events that people have decided to agree upon.
—Napoleon Bonaparte

MEYER'S LAKE TREASURE, CANTON

As Edward rolled over in his heavy slumber, he was nudged awake by the baying of one of the horses out in the barn. He recognized the chuffs from the curious Thoroughbred as a warning to a stranger in or near the barn. Slowly, Edward moved to the window, as he was not really alarmed. In the full moonlight, he could make out the distinct shapes of two men creeping about the property. Edward glanced at his Dueber timepiece illuminated by the light of the moon. Ten after midnight; these fellows were right on time. Probably another half dozen or so co-conspirators were down trampling about the lake located on his property as well.

Perhaps Edward should have raised an eyebrow. After all, he had a barn full of Thoroughbred racing horses of national fame and a mansion full of expensive material furnishings and priceless family heirlooms. Yet Edward knew the trespassers were not here for the obvious. They were here to search for a greater prize that had brought many midnight visitors for decades now, the number increasing greatly over the last fifty years since Grandfather's death and skyrocketing after the kettle of gold was found in Akron a week ago. "Let them dig," he mumbled as he made his way back to the bed. Perhaps they could put an end to the mystery.

Over one hundred years later, the mystery is but a paragraph found on various treasure hunters' forums. In fact, many locals of Canton have no idea that such a legend once circulated the neighborhood. The Meyer family, to whom the lost treasure story refers, is more noted for another treasure of sorts: the beloved Meyer's Lake Park, an amusement park that once stood on the shore of Meyer's Lake. But long before the thrill of the rollercoasters, another exhilarating adventure was to be had by many who visited the lake area.

Born in the Rhineland and of noble stock, Andrew Meyer was raised on a hard work ethic. Both Andrew and his eldest brother, Francis, served in the Napoleon Wars and gained favor with Napoleon Bonaparte. Francis went on to become part of Napoleon's inner circle. One of Francis's many duties was to see to the safety of Napoleon's material possessions, which the leader insisted on carrying during the war. Notably, Francis stood guard of a trunk that carried gold, cash and important war documents. Later, Francis, who fought in battles as well, was given a diamond-studded insignia and bestowed the Legion of Honor by Napoleon. For his efforts and loyalty, Francis was also given a one-of-a-kind sword with diamonds in the handle. Eventually, both brothers, with their family wealth and hard-earned prizes, made their way to America, settling in Baltimore in hopes of starting a new adventure.

In 1816, Andrew Meyer made his way from Baltimore to the less-populated lands of Ohio. After supplying the United States Army with two of his ships during the Revolutionary War, he was given land in Stark County, Ohio. Earlier settlers to the region had passed it up, as it did not have many trees on it. Thus, they assumed it was not very fertile and looked elsewhere. However, Andrew was not a man to let a challenge pass him by. Once settled in the area, he helped his brother-in-law run a successful mercantile business. As he profited from the business, and with his savings from his business success in Baltimore, Andrew begin to purchase more land around his gifted property. Over the next few years, he wheeled and dealed for almost 2,500 acres, including the Wells Lake area (later renamed Meyer's Lake). He was considered one of the wealthiest men in Ohio.

Now he was ready for some real business: the construction of a family home. For five years, Andrew commissioned the building of a massive three-story, seventeen-room mansion. Brick was hauled from Steubenville. Copper for the gutters and many eaves was brought from Baltimore, as well as sturdy timber for the interior walls. Architectural embellishments, including brass locks and keys for every room, were added to further the beauty of the home. In 1822, the mansion was completed. Admiring onlookers from afar gathered to see such a grandiose palace.

Although extremely wealthy, Andrew was considered a man of "moral worth and integrity of character," as described in early historical sketches. He was known to donate money for the development of Canton. He was active in his church and showered kindness on his family and friends. In fact, it was noted that Andrew was well aware of an inhabited Indian wigwam situated on the boundaries of his property. Many even reported seeing Andrew peacefully chatting with the old Indian chief, known as Beaver Cap.

Yet with all his good deeds, people were most fascinated with the endless riches the family possessed. Was it any wonder? When Andrew and his wife traveled back and forth to Baltimore, they did so with style. The Meyers perched in their huge Conestoga wagon, loaded with their prized possessions, with twelve armed guardsmen following along on the long journey from Ohio to Maryland and back.

Likewise, media of the day would often feature stories about the mansion and the goods found within. Furnishings from all around the world, as well as priceless antiques, were sprinkled about each and every room. One item of particular interest in the house was the large trunk the sat in the third-floor hallway. This was no ordinary storage trunk. It was made of heavy iron and inlaid with jewels of many colors. Most notably, it had a secret keyhole hidden within the design. The key to open such a lock was made of iron and was large and heavy enough to use as a hammer.

As years passed, Andrew enjoyed the social scene in Canton, which was quickly taking off as an industrious city, but his passion was always in property transactions. The traditional banking system was not set in place until after the Civil War. Thus, the Meyers' transactions were cash-based, with receipts recorded in official land deeds of the time. With all of Andrew's noticeable spending and frequent reports of riches inside the grand mansion, it is no wonder that people were curious about where one would store that endless supply of money.

After Andrew's death in 1848, rumors circulated. One rumor claimed that right before Andrew's death, he was seen on Meyer's Lake, where he proceeded to sink a copper boat loaded down with unidentified objects. Yet others swore that Mr. Meyer was frequently spotted with a shovel walking around the lakeshore. One neighbor insisted Andrew buried gold and rubies near his beloved mansion. As the news of Andrew's death traveled through the county, treasure hunters scoured the property for the rumored loot.

In the years to follow, the property changed hands among the many Meyer heirs. In 1888, Edward Meyer, Andrew's grandson, took ownership of the

property, where he established riding and breeding stables for only the best horses, complete with an indoor track to exercise the Thoroughbreds.

As Edward went about his business on the property, he occasionally ran across folks on his land with pickaxes and shovels on a quest for his grandfather's riches. However, in 1901, a surge of interest in the treasure story took hold when a kettle of gold was unearthed in nearby Akron. Motivation for the Meyer's Lake treasure was renewed, and people came from afar in search of it. Not uncommonly, people went so far as to hire local clairvoyants to conduct séances for one dollar each session in hopes of unlocking the secret. Some hired psychics to accompany them to the Meyers' property. Most came between midnight and 1:00 a.m., when the spirits of the dead were believed to be at rest.

Edward, a down-to-earth type, enjoyed watching the people dig. In an article in the *Canton Repository* in 1901, Edward states that "there might be some treasure hidden on my farm, but I doubt it." He also goes on to recall stories spread of his grandfather bringing a sea serpent to the lake and periodically dumping salt in the water for the creature to survive. Edward chuckles to himself at the absurdity of it all. However, Edward notes that his grandfather did have plenty of money, and banks were iffy at the time; he admits there is a possibility Andrew might have buried money, as was the norm in the olden days.

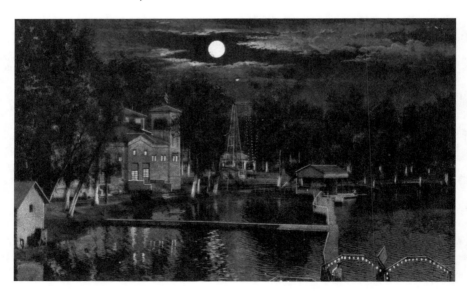

A postcard depicting Meyer's Lake Park in the moonlight. *Author's collection.*

In the following years, the Meyer family furthered the Meyer's Lake Park concept that Edward's father had started. Eventually, the entire west shore became a popular amusement park, drawing crowds by the thousands each summer until the 1970s. Perhaps these summer vacationers were stomping on an almost forgotten amusement: the legendary buried treasure.

As the decades passed, the homestead was passed from one generation to the next. Parcels of the property were sold off as the farming lands were no longer being cultivated. By the 1970s, the mansion plus ten woodsy acres were all that was left on the once expansive property. The single-family housing developments of the 1930s and '40s cluttered around woodsy Meyer's Knoll. The owner of the time, Andrew's great-great-granddaughter, chose not to live in the house. Thus, the place sat vacant for many years. An article in the 1940s about the historic house reported that neighbors described the mansion as "moody and mysterious," and youngsters were certain it was haunted.

The amusement park, as well, was just a shadow of its heyday; only small houses and picnic shelters remained around the lake.

Meyer's Lake as it looks today. *Author's collection.*

In 1975, firemen were called to Broad Avenue and Twelfth Street to a fully engulfed three-story home. Vandals, who frequented the house, were believed to have set the fire. The interior of the house, along with whatever contents had not been stolen, burned to the ground that October night. Only partial stone walls remained intact.

Today, the legend holds that it was not gold and rubies buried but rather a huge trunk belonging to Napoleon Bonaparte. The trunk is said to contain the French captain's payroll, coins and perhaps some diamonds. Of the few who even know of the story, they are certain the lost treasure is between the mansion and the southern shore of Meyer's Lake. Perhaps one day the treasure will emerge—along with the bones of an old sea serpent.

SIXTH-FLOOR DIVA, AKRON

The old lady scrambled to unlock her door on the sixth floor of the Portage Hotel in downtown Akron. Although she was decked out in a stunning party gown, accented with a diamond necklace, her body language suggested that she did not want to be seen. She carried a heavy grocery bag laden with cans of soup and vegetables. After fumbling with the key for a bit, she succeeded in opening her door and slipped quietly into the darkened hotel room that she had called home for nearly thirty years.

Later that same evening, the old lady was awakened by fits of coughing. She had been fighting this illness for days now, and it was only getting worse. In the morning light, she made her way out for medical treatment. She was quickly admitted into Akron City Hospital, where she suffered a few more days with the pneumonia. At eighty-three years old, and with no family members or friends by her side, Francis Louise Butler quietly passed away that cold day in January 1949.

As word spread throughout the neighborhood, hotel staff and authorities realized they would need to tend to the now vacant room. Minus the ball gowns and glitzy party dresses hung about the room, the place seemed quite ordinary. Yet once authorities opened the closet, they quickly found a massive amount of bank bonds, rolled in newspaper, totaling $300,000. This find propelled the team to keep looking for other such items.

In a trunk, the searchers found $20,000 in stock certificates. Likewise, Akron and New York bank books were found recording $13,000 deposited for safekeeping. Perhaps the most interesting items were the sugar sacks

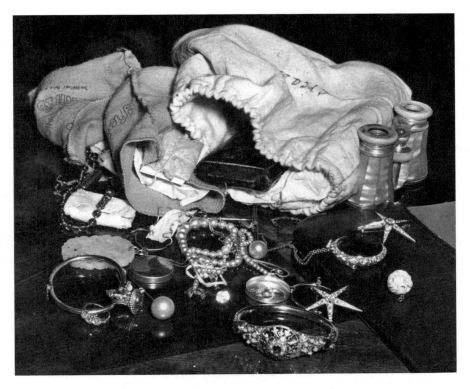

One of the sugar sacks found stuffed with valuables. *From the* Akron Beacon Journal *Digital Archives.*

stashed in dresser drawers. These sacks were loaded with diamonds, pearls, rubies and jade. All in all, the strange recluse of room 648 was worth $1 million.

So who was this lady of treasure? According to one local *Akron Beacon Journal* reader in 1949, the name rang a bell. Apparently, Francis Louise Butler had been an opera star in New York and Cincinnati. The informant reported that he remembered playing in the orchestra while the star, Ms. Butler, stole the show. An 1890s newspaper clipping was found in Francis's room stating that she was "one of the most beautiful women of New York." For years, she had owned the opera stage in both states. Likewise, she was invited to sing at the bier of President McKinley after his assassination. "Oh Promise Me" was the song of choice that day.

With more research, authorities learned that the Butler family had moved to Ohio in the 1890s. The family opened a chain of small markets throughout

A portrait of Francis Louise Butler in her glory days. *From the* Akron Beacon Journal *Digital Archives.*

Akron. Meanwhile, Francis traveled between New York and Ohio. When in Ohio, she requested her favorite room on the sixth floor at the Portage Hotel. When she was not starring in shows, Francis acquired property in Akron, amassing seventy-five houses and buildings.

In the early 1900s, the opera star decided to retire from the opera and concentrate on her properties. For thirty years, she lived a hermit-like life in

Two of the many people who came to pay last respects to Ms. Butler. *From the* Akron Beacon Journal *Digital Archives.*

her hotel room. Neighbors got the message that they were to basically leave her alone. Her one visitor was the local pastor, who took it upon himself to befriend the lonely. He later repeated the stories Francis shared about her stardom days. The reverend reported that he was not at all interested in her money but found a good friend in the spinster.

As papers across the country picked up the story, it seemed as though members of the Butler lineage came out of the woodwork. The court resorted to using genealogical charts and records to sort out these distant relatives. Eventually, it was found that one hundred people had blood ties to the inheritance.

However, after reviewing the case, the Ohio courts found that Ms. Butler was not much for paying income taxes or property taxes in her day. Thus, after the government took its cut and the court costs were totaled, the $1 million had dwindled to $368,000. Not a whole lot when divided by one hundred long-lost relatives.

The body of Francis Louise Butler was shipped to be interred in the family plot. Francis made her last trip to the state of New York, where she was once a treasured member of the opera.

A GIANT OF A TALE, SEVILLE

"Dang blast it!"

If Martin banged his head on that doorframe one more time, he was going to take a sledgehammer to it. Sure, the doorframe was a standard six feet, two inches tall, but neither Martin nor his wife, by any means, were the standard. One size fits all did not apply in this case.

Born in 1843, Martin was the youngest of twelve siblings. For the first few years, everything continued in a normal fashion on the Bates farm. The children were assigned only a few chores each, as they were to concentrate on their schooling. At age six, however, Martin hit his first real growth spurt.

His parents were quite concerned with Martin's "rapid elongation." Thus, they assumed he must be a delicate child and forbade their youngest from doing chores. On Martin's eleventh birthday, he weighed in at 170 pounds, and his uncle exclaimed upon seeing the lad, "That's a mighty big boy, by heck!" At age twelve, Martin received a custom-made, good and sturdy bed from his father. It was long enough to fit the six-foot-tall boy.

With education always being of utmost importance, Martin received his teaching degree in his later teen years. The children in the small Kentucky school had no trouble obeying their seven-foot-tall teacher with a voice that "rolled like a bellowing bull." However, most children reportedly liked their teacher and received a good education under his instruction. Unfortunately, Martin was soon called away to join the Confederate army in 1861.

Meanwhile, another young person was making her mark on the world. Anna Swan was born the thirteenth child to a petite mother and average sized father in Nova Scotia, Canada. Weighing eighteen pounds at birth, Anna's size was noted from the start. Regardless of her growing tendencies, Anna was well educated and blossomed into a bright, cheerful young woman.

In the early 1860s, Anna was hired by P.T. Barnum as part of his Gallery of Wonders in New York City. For a twenty-five-cent admissions fee, guests of the museum were treated to miraculous attractions, including the giant woman who stood seven feet, eleven inches tall and weighed 413 pounds. Anna was compensated with "impressive financial considerations," private tutoring sessions, room and board and the finest designer original gowns available. In the Lecture Room of the gallery, Anna was visited by thousands of guests and quickly rose to international stardom. Yet her young woman's heart was longing for something more.

In 1869, Martin, now a Civil War veteran, returned to his hometown in Kentucky. The "Kentucky Giant," a whopping seven-foot-nine, 470 pounds,

was soon asked to join a circus in New Jersey, which was about to head out for a European tour. Martin accepted the job, as he was particularly interested in traveling the world. Anna Swan, as well, joined the traveling team; she, too, was longing to experience all life had to offer. In 1871, the troupe set out across the Atlantic Ocean. The stars were definitely aligned when viewing them from that old ship's deck, for a romance as big as the night sky was emerging. When the ship docked, Anna and Martin were officially engaged.

The couple had much in common from the start. First, they both were the youngest of a dozen-plus siblings. Second, both Anna and Martin cherished education and learning. Both were said to be of great intelligence. And the young adults were now in the same line of work. And, of course, there was the whole issue of size—only a giant could completely understand the heart of another giant. Thus, to the delight of circus officials, the two became "the World's Tallest Couple."

In 1871, the couple was invited to wed at Buckingham Palace. Queen Victoria was a great fan of the pair, and she lavished the newlyweds with gifts, most notably a diamond cluster ring for Anna and a saucer-sized diamond-studded pocket watch for Martin.

After a honeymoon, the Bateses continued work with the circus, accumulating a handsome income between the two. However, neither fame nor fortune could protect against one of life's most horrible experiences.

In 1871, Anna gave birth to a baby girl, the largest born at the time. Sadly, the baby was stillborn, and the experience was devastating to the young mother. The couple soon returned to the United States and continued working while looking for a place to call home. The Bateses settled into the little town of Seville, Ohio, and Martin took up his lifelong dream of farming. He built a farmhouse meant for giants, complete with giant-sized furniture, fourteen-foot ceilings and eight-foot doorframes. Martin stocked his farm with the best of horses and enjoyed harvesting crops. Periodically the Bateses would travel with a circus.

Perhaps it was Anna's glorious gowns, Martin's watch from Queen Victoria or paychecks from the circus that caused treasure tales to spread within the communities of northeast Ohio. One thing was certain: the giant couple had to have a giant purse, and people knew just where it was kept. The townsfolk were certain that the Bateses stashed their money, jewelry and gold coins right on the property. After all, who in his right mind would get caught digging up a giant's garden? The giants were quite clever to keep their treasure buried right on the property, according to local gossip.

Regardless of rumors, life for the Bateses continued. They were active members of the Seville Baptist Church, where they had an extra-large pew built just for them. The Bateses loved to entertain guests, especially old friends from the circus. They socialized in town and seemed to genuinely enjoy the community. Once while in town at a party, the floor of a building collapsed under the weight of the dancing giants.

In 1879, the couple learned that Anna was with child once more. And once again, Anna gave birth to the largest baby on record—a twenty-three-pound, thirty-inch-long baby boy, holding the record to this day. Heart wrenchingly, Baby Bates lived only eleven hours.

It was said that Anna never recovered from the loss of her babies. Ten years after the second baby was lost, Anna, at age forty-one, died of heart failure, much to the heartbreak of Martin. To add to his grief, the coffin-making company in Cleveland sent a normal-sized casket; workers assumed the original order sheet was incorrect in measurements. The funeral had to be postponed three days while they waited for the right size coffin to be constructed. Martin later would order his own giant-sized casket and store it in the barn to spare his loved ones the same mishap.

Eventually, Martin married again. This time, he married a local woman of average size. He never traveled with the circus again, although he would attend some shows in order to visit his old co-workers. Martin moved from the "giant" house and lived in the town of Seville with his new wife. In 1919, Martin died of a kidney disease and was interred into the ground next to Anna and their infant son. Today, the family plot brings hundreds of tourists to the Mound Hill Cemetery in Seville.

In 1948, the giants' farmhouse was torn down. No reports of treasure have ever been reported. However, the story of the Bateses, their love, their faith and their giant mark on the world is the best treasure of all.

OHIO'S PIRATE, DELAWARE

In the early 1800s, the small town of Delaware, Ohio, was just that—a small town. Like most small towns, there existed a few churches, a school, various shops and a hotel. And like most other small towns, everyone had to know everyone's business. So when a handsome fellow carrying bags and paying for items with gold coins came to town, the small town just had to know this

man's business. To the dismay of many, the fellow was not willing to share and quietly kept to himself. In fact, he was not very friendly at all.

Many times he was seen going to and fro in the woods that lined the Scioto River. Starting after breakfast and then returning to a tavern for supper, the man spent his days deep in the rugged forest. What could he possibly be doing in there?

After a few weeks of this mysterious travel, the man, who called himself John Robinson, purchased some of that woodsy land, near present-day Concord Township. And lo and behold, he built a mansion, sometimes called a castle, right on the banks of the river. Every pack train that came through town stopped with a trunk or box for John Robinson. His money for supplies seemed limitless.

The townspeople must have been desperate for information after this latest stunt. Thus, they set to spying on the man. Many times, he was found in the woods around his house. Often he was found stooped down as though digging for something. Other items of interest were the luxurious furnishings shipped into town and then out to the mansion. Most curiously, John was spotted for hours sitting in front of an easel, painting canvas. Yes, this John Robinson was up to something, and the people were going to find out exactly what it was.

That chance came one month while John was away on a trip to England—more evidence of his riches. A few of the men made their way out to the property and reportedly entered the house. To their delight, they found numerous paintings lining the wall. These paintings, especially one, served as clues. The biggest painting was that of an old sailing vessel. Amid the vessel stood a tall man in what appeared to be pirate's garb. The pirate was none other than John Robinson.

Finally, the people had their answer. Mr. Robinson was a pirate, hiding in mid-Ohio and stashing his treasure throughout the adjacent woods. And treasure was not the only thing he supposedly buried out there.

As months turned to years, the people kept a close eye on their pirate. Every so often, they would see John with a beautiful European woman. When she arrived, no one could say. Then, late one night, coon hunters heard the anguishing cries of a woman in the woods. The lovely lady who had accompanied John to town was never seen again. However, to this day, people near the river report hearing the terrifying cries of a woman.

In the late 1830s, the community realized they had not seen John in quite some time. Thus, they made the trek out to his mansion and let themselves in. The house was empty of life. However, the paintings and other furnishing

were left intact. One painting of interest was that of a beautiful European woman who seemed to watch the men from within the canvas.

In 1959, Louis Foster, then a twelve-year-old lad, was roaming about the countryside in Ostrander, Ohio. His main goal for the afternoon was to locate a good crop of tadpoles and frogs. As he wandered near the edge of town, he came across Mill Cemetery. There he found the gravestone of John and Elizabeth Robinson. He immediately recognized the names of his great-great-grandparents. Interesting as it was, Louis had more important things to do with his day. It would be nearly forty-five years before he visited the grave site again while researching his family tree.

Louis was intrigued by the legends of great-great-grandpa Robinson. As he dug deep into the family history, he discovered many aspects of his grandfather's life that may have led to the pirate and treasure stories.

For one, John Robinson had money. He came from a wealthy family in England, and he was commissioned to write a book concerning the flora in the United States. John also had a beautiful wife, Elizabeth, who passed away almost fifteen years before him. Talented in the arts, John spent hours working on his glorious masterpieces. He built a grand mansion right there in the woods of Concord Township. Sadly, John's research for his book, his plant samples and many of his paintings were lost in a shipwreck en route to England. Eventually, the house was looted of all its treasure.

The remains of the John Robinson homestead. *Courtesy Duane Bargar Collection.*

In 1845, the house burned to the ground, with only a few pieces of foundation left. Stories of the pirate, his ghost, the murdered woman's ghost and the lost treasure continue today. The entire area where John established his property is now part of the O'Shaughnessy Reservoir. If there is a treasure, it is under water—a great resting place for pirate's gold.

Chapter 6

SUNKEN TREASURES

There is something in a treasure that fastens upon a man's mind. He will see it every time he closes his eyes.
—Joseph Conrad

MARQUETTE AND BESSEMER 2

It was a typical run for the ship. The car ferry *Marquette and Bessemer 2* had made this trip from Conneaut, Ohio, to Port Stanley, Ontario, dozens of times in the last four years. Generally, the ship would be loaded with rail cars, most filled with coal, in the early morning hours. About 9:00 a.m., the ship would set out. The five-hour trip was practically a straight shot across Lake Erie. The shipment would arrive about 3:00 p.m. in Ontario, where it would be unloaded. If all went well, the ship, the crew and the empty rail cars would dock at Conneaut about 10:00 p.m. It was a good shift for a sailor in those days. However, on December 7, 1909, a smooth voyage was not in the forecast.

The day started out fairly normal, minus the lingering dark clouds over the lake. About forty degrees Fahrenheit, it was not the coldest day the crew had ever faced. A last-minute passenger, Albert Weiss, treasurer of Keystone Fish Company, had paid passage in order to make a hefty real estate purchase in Ontario. He supposedly came aboard with $36,000 to be placed in the safe of the ship.

When the car ferry set off about 9:30 a.m. loaded with approximately thirty rail cars, the thirty-six crew members set about their assigned jobs.

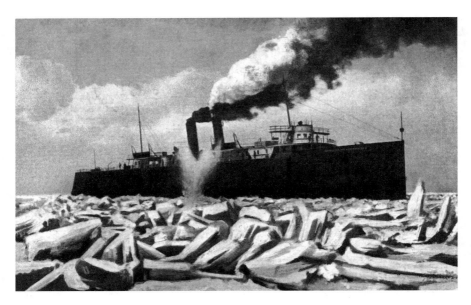

A postcard showing the size of the missing *Marquette and Bessemer 2. Author's collection.*

A few hours into the trip, however, a biting wind picked up across the lake. The temperature fell to ten degrees, and the wind increased to about eighty miles per hour, producing fifteen-foot waves. Darkness set in early this time of year, adding to the misery of the situation.

What happened next on the final voyage of the *Marquette and Bessemer 2* is a frenzied entanglement of eyewitness and onshore reports. Most believe that the captain tried to make it to port in Ontario. When that proved impossible, he most likely ordered the ship to be turned around and headed back for Conneaut.

People in Port Stanley reported hearing the distress horn at 1:00 a.m., yet people in Conneaut insisted they heard the whistle around the same time. Other ships that were out on the lake around the same time reported seeing the *M&B2* at various locations on the lake. The weeks following the storm, the reports of sightings from shore to shore were like the path of a ping-pong ball.

Perhaps the most vivid onshore account came almost ninety years later. Gladys Eagley of Conneaut remembers waking her dad at 3:30 a.m. Over the wind and the waves, Gladys could hear a more frightening noise. Her father explained that a ship was in trouble out on the lake, and it was blasting a distressed single.

In 1986, Gladys wrote a letter to the captain's niece. Gladys explained:

> *On the night the carferry went down we heard the whistle it kept blowing and Dad says that boat is having trouble we did not know then untill we heard the news.*
> *But that whistle keep blowing untill it went under water.*
> *I just had to write and tell you, I am 93 years old and I can still hear that whistle.*
> *So this is my story.*

Regardless of the reports, searchers were unable to locate exactly where the ship went down. On December 11, a small steamer sailed through a debris field off Long Point. Later, it was determined that the wreckage pieces were that of the *M&B2*. However, the debris had floated in rough waters for five days. Thus, the wreckage offered no indication of the location of the hull.

On December 12, about fifteen miles off Erie, the *Marquette and Bessemer 2* lifeboat number four was found drifting along, carrying in it nine bodies. Newspapers reported that four of the corpses were frozen in sitting position, and another four were huddled on the floor over a body, as if trying to keep it warm. Also, a set of clothes was found frozen to the bench of the lifeboat, suggesting that another had made it on the boat only to bail or fall off sometime in the chaos. As the lifeboat was pulled to shore, hundreds gathered at the wharf to get a look.

The body of Albert Weiss and his money were never recovered. However, ship divers of today are not at all concerned over the lost money. Instead, the disappearance of the *Marquette and Bessemer 2* is one of greatest mysteries of Great Lakes history. How could a ship as long as a football field, fifty-five feet high and loaded down with thirty-plus cars simply disappear? Over a century later, not a clue has surfaced to its whereabouts. Reports on the location are as numerous and confusing as that of the firsthand reports. Consequently, the wreck is considered the "Holy Grail of Great Lakes Shipwrecks."

Regardless of the theories, searches and accounts, one fact remains: the *M&B2* simply vanished into the night. It is said that on cold winter nights, the distressed whistle of the missing car ferry can be heard mournfully crying out across the lake.

BEACH BUCKS, GENEVA

The water temperature was a cool seventy-four degrees on that hot July day in 1963. Children could be spotted up and down the shoreline from Madison to Geneva on the Lake. The previous day, a huge storm had whipped the lake into a dangerous frenzy. Thus, beachgoers lost a full swim day. Thankfully, today was an ideal Lake Erie day, and people were eager to make up for lost time.

Eleven-year-old local girl Patricia was busy enjoying her favorite activity: exploring the sandbar about seventy-five feet from shore. As she dove down between the waves, her hand brushed on what she thought was paper. After coming up for air, she went back down again with intentions of pulling the strange item up from the bottom. As she blinked the water droplets from her eyes, she realized she was holding a handful of large-denomination bills.

Quickly, Patricia alerted her comrades, and the newly formed children's diving team began their first successful expedition. Patricia's sister found nearly $60. And their young friends from Pittsburgh, vacationing down the way, both found handfuls of cash as well. All in all, the team collected nearly $500 that day.

A few days after the money washed ashore, Carl Pretz, who owns beachfront property in Madison, was walking along the shore. Lying on the beach was part of an airplane. Carl, being somewhat familiar with the mechanics of a plane, recognized it as a piece from a tri-motor Ford plane. Likewise, a neighbor found part of the undercarriage of the plane, which he used as a decorative item in his recreation room.

With the clues now in place, the money and the aircraft parts most likely belonged to a missing Grumman Mallard airplane that had crashed in the lake in 1951.

The amphibious plane belonged to General Tire and Rubber Company in Akron. This voyage from Akron to Toronto was commissioned to Canada in order to pick up the newly hired head of the Bowling Green branch of the company. On board were the pilot and co-pilot and the pilot's close friend.

All was going well until the pilot decided to make what was believed to be a test landing about three miles off the shore of Geneva on the Lake. Witnesses on the beach saw the plane coming in fast. The pilot tried to pull up, as he knew it was a failed landing, but it was too late. The plane plunged into the water, and the roar of the engine came to an abrupt stop.

Nearby, a lake freighter carrying ore, belonging to Jones and Laughlin Steel Company, was making its way east to Ashtabula Harbor. One of

the deckhands had watched as the plane made its descent into the lake. The cumbersome ship slowly turned around and proceeded on its first rescue voyage.

Likewise, in Geneva on the Lake, Lenard Geatano had been informed of the commotion. Gaetano hopped in his speedboat, docked and ready for takeoff, and was the first on the scene of the crash. He was able to locate the pilot and co-pilot. Both survivors were near exhaustion and in shock from the incident.

Unfortunately, the third passenger, David Hennessy, was not found. The coast guard, Geatano, the ore carrier and several leisure boats scoured the vicinity in hopes of finding the man or the plane where he was most likely entombed.

For five weeks, a continuous search took place in the waters for the plane and the body. Searchers determined that the wreckage was probably located anywhere from Geneva on the Lake to Fairport Harbor based on water current conditions immediately following the crash. The best equipment was used, including a dragline and a navy submarine detector. A professional diver was hired by the Goodyear Company as well, but to no avail. In the meantime, reward posters for the wreckage were issued throughout the Ohio Lake Erie region.

It appears that another item of value was sought in this plane crash as well. Apparently, Mr. Hennessy had boarded the aircraft with a bag containing $30,000. This fact was later confirmed by the diver, who was hired

A reward poster for the location of the crashed plane. *From* True Treasure *magazine, December 1971.*

not only to find the plane but also to search for a satchel stuffed with cash. Why Hennessy was carrying the cash remains undetermined.

A year later, a bit of a mystery surrounded a peculiar item found on a beach in Geneva on the Lake. In 1952, a young lad and his sister were walking along a stretch of beach known as Grand View Beach. The pair was horrified upon finding a headless corpse lying on the beach. Upon inspection of the body, the authorities found identification of a Mr. Cormick, who had been reported as a drowning victim. However, many people connected to the plane crash case were convinced that the headless corpse was that of David Hennessy.

Regardless, the plane, the body and the satchel are still listed as missing. As for the money, it is very possible that $500 of it was found twelve years after the crash by one happy bunch of children. Thus, $25,000 is possibly still hidden beneath Lake Erie's surface.

STEAMER G.P. GRIFFITH, WILLOWICK

On June 16, 1850, the six-hundred-ton passenger steamer G.P. Griffith steamed out of Buffalo, New York, on a course for Toledo. Aboard the large ship, excitement permeated the air. This was a ship full of hope for a new future. Among the passengers were German, English and Irish immigrants on a voyage to change their lives. They were bound for Toledo, Ohio, where they would purchase tracks of fertile farmland in the state under the new Homestead Act. Most had money belts or secret pockets inside their clothes where they stored their entire life's savings. After traveling thousands of miles across the Atlantic in less than pleasant accommodations, the short trip across Lake Erie should be quite easy. Nothing could be further from the truth.

On the morning of June 17, at 4:00 a.m., just before the sun peeked up over the eastern horizon, the first mate approached the captain. This ship was about an hour away from Cleveland and about a mile from the shoreline of Willowick Beach. The first mate calmly whispered that the smokestack of the ship was on fire. This was strange because the G.P. Griffith had been fitted out with a new and improved fire propellant on that stack.

The captain, sensing that things would get worse before they got better, ordered the ship to be turned toward the beach, a ten-minute course to shore. At this point, the passengers, although most did not speak any English,

realized something was amiss. As they came up to the main deck, they felt a sickening lurch and noticed the orange flames above.

Now only six hundred yards from shore, the *G.P. Griffith* was stranded on a sandbar. To make matters worse, the breeze produced by the lake only caused the fire to spread. The steamer was quickly engulfed in flames. The fire from above rained down on those on the deck. People became human torches.

The only possibility of escape was to jump overboard. The terrified passengers began to jump in masses, some holding hands. Some stayed aboard and threw in trunks, chests and boxes of belongings that accidentally landed on people overboard. As for the captain, he, too, jumped into the dark water, but it was later reported that he immediately drowned.

Some of the passengers were able to make it to the shore, where they called out for others. Others were not so fortunate. Some died from fire on or around the ship. Others drowned because they did not know how to swim. But most died from panic. As they jumped from the ship, sometimes in groups of twenty or so, they clung to one another for dear life. When the entangled mass of humans hit the water, the panic fully set in, and they held tighter to each other. Later, after the recovery process, the *Cleveland Plain Dealer* reported, "They secured many hundreds, oft times finding as many as five or six of the unfortunates clinched together in a manner so firm as to require a great deal of force to separate them."

At daybreak, the scene on and near shore was ghastly, to say the least. On shore sat 130 distraught and horrified people of many different countries. Near the shore, in the sky-blue lake, perched the black skeleton of the *G.P. Griffith*. As the waves rolled in, bodies were spotted floating atop the foam, some making it to shore.

As aid came in the form of locals and shipping crews, the recovery of the dead commenced. In *Lloyd's Steamboat Directory and Disasters on Western Waters*, the author describes the aftermath:

> The scene on the shore, after the tradgedy was finished, was melancholy in the extreme. One hundred and fifty dead bodies were strewn along the beach. Boats had been employed in dragging for them at the spot where the wreck lay. A long trench was dug on the shore, and here the greater number of the dead were interred, unshrouded and uncoffinned, and many of them unknown.

Ninety-seven bodies were unclaimed. They were interred in the beach grave. Approximately 30 bodies were never found in the lake; 154 passengers survived the disaster.

In the following days, onlookers arrived at the scene. However, some in the crowd that gathered on the bluffs were not there simply to gawk. Most people knew the passengers of the steamer were carrying money to set up new lives. After all, one local paper had just run a story on a deceased victim who had over $1,000 sewn into her dress. This alerted the greedy to the potential that might be lying just under the sand.

For days, local police, sailors and even locals stood guard over the mass grave. However, the grave robbers were still able to raid most graves. Locals continued to re-cover the graves with sand for weeks to follow.

As years went by, the locals tried to put the tragedy behind them. But in 1911, plans for a grand amusement park at Willowick Beach would exhume some bad memories. What the lake had not reclaimed at this point, the construction equipment dredged up. Full skeletons and bones were removed from the beach. Dozens of coins, some a century old, were found in the sand. At this point, it was determined by city officials to move the grave farther inland atop the bluffs. For years afterward, the park would be rumored as haunted.

The *G.P. Griffith* historical marker at Lake Shore Park in Willowick. *Author's collection.*

In 2000, an Ohio Historical Marker was placed on the hill overlooking the shore. For many, this was the first time they had heard of the 150-year-old ship disaster. Many treasure seekers and divers today still scour for treasure near the wreck site. A coin worth forty cents then could now be worth $400. But there could never be a value put on the lives that were lost that tragic morning. The wreck is considered one of the worst in maritime history.

PYMATUNING LAKE MYSTERY

The nearly eighteen-thousand-acre man-made Pymatuning Lake straddles the Ohio and Pennsylvania line in northeast Ohio. Before the creation of the lake reservoir, the area was a treacherous swamp, avoided by most settlers. At the turn of the century, engineers pleaded for the construction of a dam in this location due to flooding. The project was consistently ignored, until the Great Flood of 1913. Suddenly, the $5 million price tag did not look so bad in light of the flood's $3 million worth of damage and hundreds of lives lost. In 1934, the construction of the reservoir was actualized.

Today, Pymatuning Lake is a popular recreational destination. Two scenic state parks, one in Ohio and one in Pennsylvania, fill up with nature lovers, campers, fishermen, hikers and sunbathers each and every year. Yet what most visitors do not know is that a mysterious treasure lies on the bottom of their beloved lake.

The Delaware Indians named the swamp the "dwelling place of crooked mouth man." The man they were referring to might have had a strange-shaped mouth, but the name was given to represent the "crooked ways" of the Indian tribes who lived there previously. If that was not enough, the Delawares also reported that a "great spirit of many shapes" arose with the moon and roamed about the twenty-three miles of swamp during the night. The tribe was convinced that a sinister presence lurked about the entire region.

As white men settled in the nearby areas, they, too, revered the "mysterious wasteland" as a mystical playground for ghosts and water monsters. And the fact that the evil "savages" strolled right into the bog and spent the day hunting therein only confirmed the white man's suspicions. Thus, more tales were created that are still shared today.

One such tale involves a fallen eagle's nest. A few early pioneers, upon investigation of the nest, found the bones of a human baby. Determining

A map of Pymatuning Lake and surrounding areas. *Author's collection.*

the reasons the bones were in the nest seems to be part of the fun of telling the story.

Another story is one of unrequited love. Apparently, a young Indian man got up the nerve to confess his love to a beautiful Indian maiden. The

results were not what the young man was hoping for, as the girl denied his affections. So one moonlit night, he asked the girl to take a ride in his canoe. She hesitated at first but could not resist the adventure. Once in the deep reaches of the swamp, the love-struck youth made one last attempt to establish a romantic relationship. When he was rejected once more, his affectionate feelings turned into burning hate. He rammed the canoe into a deadly patch of quicksand and watched as his love, his canoe and his dreams sank deep into the earth.

Throughout the years, it seems that this land has had the stuff of which good legends are made. From the initial fears held by Native Americans to white man's stories told around the campfire, the lake area provides a perfect setting for great mystery. However, one story—a treasure tale of sorts—is, in fact, based on a concrete find that now lies on the bottom of the lake.

In 1827, early settlers reported finding a huge hulk of a ship partially sunken in the swamp. It had a two-foot tree growing from the starboard side, suggesting it had been there for quite some time. Likewise, the bow of the ship was several feet deep in the mud. The ship measured sixty feet long and twenty-two feet across the beam. The early report estimated that this abandoned ship was a Durham-type sailing ship.

Again in 1850, two locals, an Ohioan and Pennsylvanian, explored the "wasteland of creeping things, wild animals, and spooks." These gentlemen

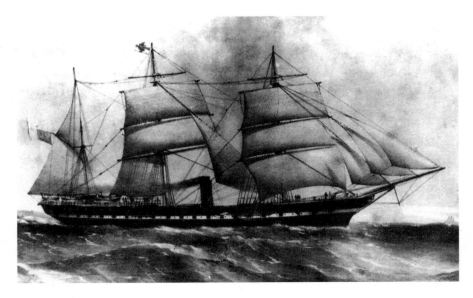

An illustration of an early Durham sailing ship. *Wikimedia Commons.*

found the mystery ship. According to an article by Carl Feather of the *Ashtabula Star Beacon Journal* (*ASBJ*), the men removed a piece of board from the deck of the ship and took it to Conneaut. There, one man carved the plank into two walking canes.

In the early 1900s, a local fellow by the name of Robert Cotton explored the remains of the old sailing vessel. He reported that it was covered in bulrushes and cattails and sunk down deep into the mud. Many farmers in the area came to investigate the find. And children of the day clamored about the old girl, spinning tales of pirates and missing treasure.

In the 1930s, the plans for the reservoir were set in stone. The swamp would be flooded in the next few years during the construction of the reservoir. Anything sitting in the bottom of the swamp would soon be covered in approximately fifteen to forty-five feet of water.

As the dam started to fill, two local gentlemen explored the mystery ship one last time. They reported the hull constructed of foreign wood, and they recorded the copper riveting. The location was noted at approximately twenty feet from the mouth of Pymatuning Creek. They, too, were clueless about the origins of the vessel.

Four theories concerning the old ship have circulated the region for centuries. All four tales rely heavily on the geography of several waterways in Ohio and Pennsylvania.

The first suggests the ship is one of Hernando de Soto's, the first European explorer to cross the Mississippi River. In the 1500s, Soto and a team of six-hundred-plus men, seven sailing ships and hundreds of livestock set sat sail from Spain to North America.

Soto and his crew landed in Florida and ended their exploration in Texas. They did not come anywhere close to the present-day Ohio border. However, they did encounter the Mississippi River, which connects to the Ohio River. The Ohio River connects to the Shenango River near Beaver, Pennsylvania. The Shenango River eventually leads to the Pymatuning area. Perhaps one of the ships in Soto's caravan was commissioned to follow this river trail. However, if the heavy ship made it to the swamplands of northeast Ohio, it would have become stuck in the black ooze.

A second theory, according to Carl Feather of the *ASBJ*, was a more romantic tale. Like the purposed Soto theory, the ship started its voyage at the Mississippi and followed the river trail to the Shenango. Geographers suggest that the Shenango may have stretched as far as Lake Erie at one point. This voyage was not one of exploration, however. On the ship was a beautiful Castilian princess on her way to wed a French Canadian nobleman.

This was not only to be a wedding between the couple but also a political wedding between France and Spain in an attempt to join forces against the English, who were overtaking America.

However, the ship never made it to Lake Erie. The princess, her dowry of one hundred doubloons and three smaller boats were last spotted on the Ohio River entering the Shenango River region. The groom was left without a bride.

A third tale is rather practical in nature. With the belief that the Shenango met up with Lake Eire in Ashtabula County, it is easy to assume the mystery ship simply sailed in off the lake. The river carried the ship right into the swamp, where its bulk became grounded. With legends being as they are, the crew of the ship reportedly disappeared.

The last and most realistic explanation suggests that the ship belonged to traders from Pittsburgh who frequented the river ways in both states. Once making their way up the river and into the shallow swamp, the traders realized the ship was a lost cause. They simply unloaded the vessel and made their way home on foot.

Regardless, a mysterious abandoned ship did exist in the Pymatuning Swamp region. Whether through a romantic voyage or a practical one, the ship's last cruise landed it here. Possibly only the spirits of those who rise with the moon will ever really know how and why the ship came to be abandoned so long ago.

Chapter 7

ROOT OF ALL EVIL

For the love of money is a root of all kinds of evil. Some people, eager for money,
have wandered from the faith and pierced themselves with many griefs.
—1 Timothy 6:10 NIV

GRAVEN TREASURES, NEW PHILADELPHIA

In the 1880s, medical schools in Ohio, as well as across the United States, were in desperate need of donations. Students needed some hands-on experience, and the colleges were willing to pay big bucks to offer it. Bodies, in particular dead ones, were sought to fulfill this learning gap. But where to find them?

As it was, some outsiders were able to assist in this search. It was obvious. Where do they put dead bodies? Why, in the graveyard, of course. Thus, the concept of grave digging in America was born. Although not the typical treasure story, the body snatcher eventually earned money for his crime.

Across Ohio, graves—especially those freshly made—were dug up. Cemetery and graveyard caretakers now had the task of guarding the grounds. A rash of body-snatching crimes was reported throughout small towns. And the small towns of Tuscarawas County were no exception.

On January 2, 1881, tragedy struck the little hamlet of Palermo, a now-extinct town between New Philadelphia and Mineral City. A beloved member of Mount Tabor Lutheran Church fell dead in the isle after a church meeting. Miss Christian Hoffman, in her early twenties, showed

The church where Christian Hoffman died suddenly. Partial view of the graveyard where her body was taken by grave robbers. *Author's collection.*

no signs of ill health prior to her death. Her death was a shock to the entire community.

Services were held, and the young woman was interred in a small grave in the churchyard. As the snow fell quietly to the ground, her grieving family and friends said goodbye one last time. They returned home to continue the bitter grieving process, leaving Christian to rest peacefully in death.

The next day, a farmer walking near the cemetery noticed tracks in the new-fallen snow. Sled tracks in the small graveyard were very uncommon, and the farmer was suspicious right away. Upon further inspection, it became clear the new grave had been desecrated. The farmer alerted authorities immediately.

Inspecting the grave site, the police found pieces of a splintered coffin, clothes and a burial shroud strewn about the vicinity. As they unburied the haphazardly filled in hole, they found the remains of the coffin. As suspected, there was no body. The remains of Miss Hoffman had been stolen.

Soon, a call was made to an expert detective, S.R. Webb, in Uhrichsville. His first clue came from the nearby town of Bowerston. Apparently,

folks had noticed two nervous-looking men getting into a sled just that evening. By the time Webb secured a sled, it was nearly 2:00 a.m. Webb continued on toward Hagerstown on the same path he suspected the robbers were traveling.

Soon, Webb overtook the fugitives just as they turned on a road toward Leesville. When the men realized they were being followed, they attempted to outrun their pursuer. As the chase ensued, however, Webb's horse abruptly halted and went into a panicked rage, upsetting the sled. After calming the frightened animal, Webb glanced around for a snake or coyote. But it was not a creature that had spooked the horse. Instead, the nude body of Christian Hoffman had been dumped off in middle of the road. Webb was enraged at the atrocity.

The detective quickly loaded the corpse onto his sled and continued his pursuit. After a few hours of no success, Webb gave up the chase.

Before delivering the body to the family, the thoughtful police officer stopped at a nearby farm and asked for a covering. The family was relieved to have the body returned but outraged over the entire ordeal.

The case of Christian Hoffman was never solved. The body was reinterred in its resting place, and the memory of the robbery with it. By the early 1890s, heavy penalties for body snatching were enforced. Also, people were given the choice of whether to donate their bodies for the sake of science. Thus, medical schools were able to obtain cadavers through a more lawful and dignified means.

TORTURED TO TELL, TOLEDO AREA

At 3:00 a.m. near Findlay, Ohio, in April 1897, a gang of masked men entered a small brick house and kicked open the bedroom door of a sleeping family. The Blakesleys, although considered the wealthiest of the county, chose these living arrangements, as they were considered misers of the day. Thus, when the robbers gained entrance to the house, they had the entire family corralled into one room. Rebecca, the mother, shielded her children—a young daughter and two adult sons, one of whom was developmentally disabled.

The intruders quickly took control of the situation by holding revolvers to the terrified family. John Jr., who was labeled an "imbecile" in the day, made an attempt to reach the family shotgun hidden behind the bedroom door.

However, once the robbers realized what John was doing, they violently beat him over the head until he was unconscious. Later, John would die as a result. Realizing this family was intending to fight, the robbers tied up and gagged the Blakesleys. Once order was restored, the gang demanded that the family tell them where their valuables were hidden.

Meanwhile, some of the robbers ransacked the house, pulling up floorboards and crashing pictures from the walls. As the search proved fruitless and the family continued to deny the existence of treasure, the thugs became more agitated and resorted to torture. With lit torches, stolen from the local roundhouse, they burned the feet and hands of the family members in attempts to make them reveal the treasure's hiding place. The family members refused to speak. Eventually, the crooks found a roll of bills in a dresser. With time working against them, they took the cash, a few pieces of jewelry, the shotgun, a rifle and two revolvers. They left the Blakeslys tied and beaten.

The Blakesleys were well known as misers who had no use for the modern banking system. Twenty years prior to the break-in, the family

had lost approximately $18,000 to a local bank. Thus, they stashed the money raised from their four-hundred-acre farm on the premises. Likewise, they were caught up in a shady deal when an oil company bought rights to the land from John Blakesley Sr., the husband, who was reportedly not of sound mind due to age. Thus, the Blakesleys had good reason to hoard money on the vast property.

Kate and Johanna's cottage as it looks today. *Photo courtesy of James Eberly.*

In April 1900, approximately three years to the day after the Blakesley break-in and murder, two "lone, and aged maiden" sisters rested peacefully on their family farm a few miles from Toledo. The Sullivan sisters, Kate, sixty, and Johanna fifty-five, had become accustomed to the living arrangements after their brother passed away two years prior to this night. They were known throughout the area as being quite wealthy and stashing money within the house. Most importantly, they were completely alone—making them a perfect target for any would-be thief. Thus, when Kate heard the knock at a little past midnight, she should have refrained from answering the door.

Within moments, Kate was accosted by two masked men. They proceeded to beat and kick the defenseless older woman while she lay wailing on the ground. The horrid noise brought Johanna from her sleep, and she entered the main room. The men turned on Johanna and beat her into submission. Seeing that the sisters were both over six feet tall and strong farm gals, they tied up both women with the bedsheets. As with the Blakesley robbery, they tortured the sisters and demanded valuables as they proceeded to ransack the house. With a meager $325 in hand, they turned to the sisters, who lay unconscious on the bloodied kitchen floor. The men discussed whether to "finish them off" but decided both ladies were dead, so they left the property. A few hours later, Kate freed herself and crawled to the neighbors for help. She died the next morning. Johanna, on the other hand, survived and would later testify and help convict her sister's killers.

Another year passed without a concrete lead in the cases. Authorities were not even sure if the two incidents were connected. However, in 1901, with another robbery/murder case, the pieces of the puzzle began to fall into place.

Following the same MO of the two previous murders, robbers gained access to a farmhouse in Carey, Ohio. Here they were in search of William Johnson's (the Ohio Celery King's) money. As they gained access to the house, they did not waste time with a beating. Instead, they shot William and bound his wife and children. They held guns to Mrs. Johnson's and her children's heads demanding money. The robbers were well aware that the family had sold an entire cart of vegetables at the market that very afternoon. Soon, with an unknown amount of cash in hand, and after partaking of a light lunch at the Johnsons' home, the murderers sauntered out the front door.

In all three cases, the victims in the crimes were defenseless families living in secluded farming areas, and most importantly, they were well known to hide their valuables on the property. Northwest Ohio papers and police warned residents to be on guard, especially those who fit the victim profile.

Within the year, two brothers, Ben and Al Wade, were apprehended for the murder of Kate Sullivan. Apparently, Ben Landis, leader of the notorious Landis gang, had "squealed" on his gang members for a plea bargain in the Sullivan trial. Landis reported other crimes by the gang, which led to the capture of four additional members. Finger pointing among all the men continued as each was brought to trial. Eventually, all six men were convicted in one or more of the three northwest robberies.

Notably, Al and Ben Wade would be the sixth and seventh murderers in Ohio to be sentenced to the electric chair. The four other criminals were sent out to serve life sentences on work farms, with one being released ten years later when the Ohio governor found him not guilty. As for the snitch and gang leader, he lived out his life without parol between the damp, dank walls of the Ohio Penitentiary. Before his death, he was noted as saying, "This is a punishment worse than death." Upon his death at age seventy, "Old Ben, being unmourned and unclaimed," was placed into the cold ground by an undertaker's helper.

OSCAR OSBORNE, RICHFIELD

If there was one thing people knew about the aged farmer, it was that he hid money on his property. Oscar made no secret about it. When neighbors warned Old Oscar that he was a perfect target for robbers, the farmer replied, "They will have to find it first." However, Oscar was not totally oblivious to potential danger. He was known to carry a pistol, and he did not set foot out after dark.

Oscar had lost his wife thirteen years prior. Recently, his developmentally disabled son, whom he cared for, died of sunstroke. Oscar's other children lived about the state and occasionally visited. Although some accounts concerning Oscar Osborne labeled him as an eccentric hermit, this seems not to be the case. In fact, it seems that Oscar and his family were well liked in the community, and the little hamlet is still referred to as Osborne Corners. Neighbors later reported that they never heard an "unkind word" from Oscar.

So on a warm Sunday morning, it was uncommon to find the Osborne cows bellowing in neglect. Two young lads playing in a nearby farm were alarmed at the sight of the cows. Oscar was a great farmer, and he always tended to his animals. The boys rushed home to tell their father about the

The shed where Oscar Osborne's mangled body was found. *Author's collection.*

odd sight at Old Oscar's place. However, the sight in the pasture was nothing compared to the scene that was about to be discovered.

On September 27, 1898, neighbors searched the farm fearing that the farmer had an accident. After a futile search of the house and barn, the search party was just about to give up when Smith yelled out from the cowshed.

There, in a crumbled, bloodied heap, shoved in a manger, lay the body of Oscar Osborne, his "head beaten to jelly," as would later be so descriptively reported in papers. There was also a cord wrapped around his neck; suffocation was later listed as the cause of death. The coroner would also report that the elderly man must have put up one "hell of a fight" based on the defense wounds on his hands and arms.

Immediately, the sheriff and local detectives were called to the homicide scene. Quickly, the motive was determined to be robbery. Oscar was known to carry a large sum of money on his person. His pockets had been pulled out and emptied. Upon further inspection, authorities realized the house and barn had been ransacked as well.

Suspicion was initially aimed toward the vagrants and tramps who loitered at nearby Whipps Ledges, a nook in the hillside set back into the woods. Yet this crime seemed a little more personal than that. After speaking to the concerned folks of Osborne Corners, police learned that a buggy had been seen at Oscar's place about 4:30 p.m. on Friday, two days before the body was found. The mother-daughter duo who spotted the buggy also noted a man standing near the gate of the cow pasture. And they could easily identify the man: Edgar Johnson.

It seems Edgar was noticed about town quite a bit that weekend. On Friday night, the farmhand flamboyantly bought everyone a round or two at several saloons. He also paid off some debt to one of the shopkeepers and paid up at the horse livery, where he had rented a horse and buggy. In fact, Edgar had brought his sweetheart out to the scene on Sunday to view the chaos at the Osborne farm. Yes, Edgar Johnson was living quite high on life. Too bad for him, the party was about to be over.

Authorities easily apprehended the suspect a few days later. Once in custody, several detectives questioned Edgar over the course of four hours. Apparently, Edgar confessed to the robbery/murder and signed his name to a confession statement.

Edgar had worked for Oscar a year earlier. The farmhand remained in the area working various other farms, the most recent being only a mile from the Osborne farm. Edgar gave no reason for why he was not working for Oscar this year. Later, Oscar's daughter insisted her father was fearful of the farmhand and thus carried a pistol at all times. Regardless, Edgar made his way back to the property in an attempt to do some business with Oscar.

Apparently, Edgar needed to borrow money. At first, Oscar, being a kind soul, agreed. As the men talked, however, an argument broke out. Oscar asked Edgar about $1,800 worth of bank bonds that had disappeared a year ago. When Edgar denied knowing anything about them, Edgar claimed that Oscar kicked him in the shins—and he had bruises to prove it. Whether the bruises were inflicted in self-defense or anger, they seemed not to intimidate Oscar's soon-to-be killer.

Edgar violently attacked the man some fifty years his elder. He demanded to know where the farmer hid his money. When Oscar refused to tell, Edgar picked up a makeshift club and began to beat the old man. Perhaps due to Oscar's accusations, or maybe to cover the crime, Edgar felt it necessary to finish the man off that day. With Oscar lying unconscious on the ground, Edgar pulled a cord around the victim's neck until he quit breathing.

As in many cases of today, the legal battles raged on, with Edgar retracting his confession, saying he had been intimidated by the detectives at the time of his confession. However, the jury was not to be swayed. Sensing this, Edgar's lawyer asked for the mercy plea, in which Edgar would be given life in prison rather than the death penalty. The mercy plea was a new clause added to the Ohio court system at the time. The judge granted the plea and made a statement that he was not "showing mercy" for a killer but granted it because of his "natural abhorrence to death punishment."

Edgar was sent to the Ohio Penitentiary, where he sent a letter to his mother asking for her forgiveness. He also spoke to his sweetheart, who remained by his side through the trial, explaining that she should go on with her life.

As for that hidden money out on the Osborne farm, two years after the murder, two workers were replacing some beams in the roof of the barn. Lo and behold, in the highest beam, in a hollowed-out area, the men pulled out a sack containing $3,600. A few months later, $3,000 more was dug up near the barn. According to his family, Oscar probably hid upward of $20,000 on the property.

The former Osborne house as it looks today. *Author's collection.*

Today, the farmstead is inhabited and well kept. The current family is aware of Oscar's story. They have never found any buried treasure on the premises.

THE LINHART MURDER, PAINESVILLE

Driving through the peaceful and shady Evergreen Cemetery in Painesville, one will find it a lovely cemetery and wonderful choice for a resting place. Many of the tombstones are engraved with tributes to the deceased "Rest in Peace" and "Until we meet again" are just a few of the heartfelt, affectionate inscriptions on the stones. However, in Lot 18, near an old shady maple, an otherwise traditional stone has stopped many a grave visitor in his/her tracks. On the stone of Joseph Linhart, along with his name and years of life 1867–1922, the encryption "Not Guilty" seems to jump out at passersbys.

In a place once known as Hell's Hollow near Painesville, now part of

Lakes Metro Parks, a brutal murder took place. In 1921, the battered body of Anne Linhart, age fifty-five, was discovered deep in a well on the Linhart farm. A few hours after the discovery of the corpse, a blood-covered axe and a man's bloodstained shirt were found nearby.

Joseph, Anne's husband, had reported his wife missing the day prior to the discovery. He stated that he

The Linhart tombstone in Evergreen Cemetery. *Photo courtesy of Amanda Heil.*

was visiting friends in nearby Ashtabula that day. Upon returning home around 8:00 p.m., he could not locate his wife. He informed authorities and nearby family members of the disappearance.

The next day, Anne's body was found with her head slashed open in several places. The cause of death was fairly easy to determine. However, motive remained somewhat tricky.

Naturally, authorities looked at the husband first. Anne's daughter from a previous marriage stated that Anne and Joseph had a heated disagreement over Anne's beloved heifer, a sore spot for the couple, on the morning of Anne's murder.

As evidence piled up, Sherriff Spink was convinced that Joseph was guilty of the murder. Thus, he placed the husband under arrest and booked him in the Lake County Jail. With the arrest covered, a court date with the grand jury set and an undefeated lawyer hired, the case was shaping up to be a sensational show for the county. However, a week into Joseph's stay in the jail, he took his own life.

Reportedly, on the morning of the suicide, nearby inmates heard Linhart weeping to himself and mumbling over and over, "I am innocent." Somewhere in his misery, he found strength to ask the deputy for a razor for shaving purposes. A couple hours later, the inmate was found lying in a pool of blood on his cot with his throat slit.

Joseph's lawyer vehemently declared that his now deceased client was innocent. The lawyer paid for the tombstone to be engraved with the epitaph "Not Guilty." Some say the hotshot lawyer did this to maintain his reputation of never losing a case. With no case ever tried, Joesph was never found guilty, nor was he found innocent. The case is listed in the court books as "*nolle prosequi*," translating to mean the law will "no longer prosecute."

As years have passed, the unsolved case of the Linhart murder has left a void in Lake County history for legend to fill. With Joseph's proclamation of innocence even in death over the last ninety-plus years, folks have swayed from the original beliefs concerning the crime. The little amount of research into the family history has suggested that Anne was fond of burying money on the property. Legend has it that it was not Joseph and the fight over that blasted heifer that led to Anne's murder. Instead, Anne's son-in-law simply came for the money hidden on the property. When his mother-in-law refused to give away the hiding place, he took an axe to her. Perhaps only Anne and her killer will ever know who is guilty of such an act.

The following is from the poem "Not Guilty" by Jane Noponen Perinacci:

There's a place that's called
Hell's Hollow
In north eastern Ohio
Said a ghost walks 'round
Each evening
In a pale blue dress that flows

She is lookin' for her man
He had done her wrong
Beat her up and let her drown
At the bottom of a well
In Hell's Hollow
When the law caught up
With Joseph
He was wild eyed and confused
Wasn't quite sure what
He'd done now
Only he and heaven knows

FORBIDDEN CLUES, KELLEY'S ISLAND

In 1868, the *Cleveland Plain Dealer* reported that "it" was on the rampage. The *New York Tribune*, in the same year, noted that "in Youngstown, Canton, Warren, Tiffin, Mansfield, Akron and Elyria there is a perfect craze over it." This item of craze was a small, heart-shaped piece of wood with tiny wheels and a pencil set through the center. When placed on a sheet of paper, the piece would, if not moody, answer some questions. What better question than one about hidden treasures?

The planchette was an early version of the Ouiji Board. Originating in the Victorian era during the Spiritualism movement, the board was believed to be able to answer questions from and communicate with the dead. The device was popular among those who wished to explore the religion but for the most part was disregarded as a powerless oddity.

However, in 1867, a six-page article ran in an English newspaper about the power of the planchette. The author attested to the miraculous capabilities

An early version of the planchette. *Photo courtesy of Brandon Hodge at www.mysteriousplanchette.com.*

of the plank and how his life was better because he listened to its instructions. American papers picked the story up, and within weeks, the planchette was in high demand by the public.

In 1868, the item could be found just about everywhere. People often hosted planchette parties, as the plank generally needed three people to play. Two would sit at the table and hold the board, while one sat across the room and asked the questions.

Eventually, the device found its way to a tiny island in Lake Erie—Kelley's Island. In her book *Kelley's Island 1866–1871: The Lodge, Suffrage & Baseball*, Leslie Korenco writes, "One can assume that most everyone tried it at one time." George Bristol, after ten days of sawing wood, tying up grapes and hoeing potatoes, wrote that on January 18 he "worked at Planchette in afternoon." The planchette was a source of entertainment and intrigue for the islanders.

However, two young men took their messages from the spirits quite seriously. Apparently, the planchette told the two friends that treasure was to be had on their island. This treasure could be found with the body of an

One of many "little mountains" on Kelley's Island. *Photo courtesy of Jack Wade.*

Indian chief buried under limestone on a little mountain. He supposedly had $18,000 worth of loot in his grave.

The spirit was very specific and told the men that they must not use dynamite. Therefore, when the men located what they assumed was the little mountain, they set to the tedious task of chipping away at the limestone. The men worked a schedule of 2:00 a.m. to 7:00 a.m. and then 2:00 p.m. to 7:00 p.m. After about a month, they had burrowed a hole twelve feet deep and eight feet square. Continuing for three months, the men were relentless in their search. Sadly, however, the partners could not find the treasure and eventually called it quits.

Meanwhile, Christians in America were protesting the use of the board. The Catholic Church "denounced the item as a diabolical invention." The church also threatened to excommunicate any members found toying with the object. As the Spiritualism movement faded out and the Christian churches preached against it, the planchette faded from popularity by the 1870s. Later, the new planchette, originating in Ohio, would bring the spirit board back into the spotlight.

As for the treasure of Kelley's Island, it was never found, but not from lack of trying.

LOST AND FOUND

The loser has to pay the score
He lost you and I found you
And I'm keeping you forever more.
—Elvis Presley

THE MONEY HOUSE, CLEVELAND

In 1979, a clerk at Lawson's General Store on Cleveland's west side waited patiently while some of the neighborhood children studied the selection of penny candy. The frequent guests of the store usually needed a few minutes to make such an important decision. A few hard-earned nickels could earn one a whole handful of treats to enjoy. Yet these youngsters had enough crumpled bills in hand to empty the jars of candies on Lawson's counter that eventful afternoon.

A few blocks over, another young lad was busy making his decision at Schnider's Bike Shop. It was not every day when one could just stroll into a department store, choose such an expensive item like this and pay full in cash.

A young mother, on the same day, counted out numerous bills. The grand total: $1,000! A stroll down the street, and she was now financially set for the next few months, with some to grow on.

This was no ordinary day in the little west-side neighborhood of Cleveland. Ordinary people and a construction crew had a found pot—or in this case, a house—full of gold.

People digging through the demolished house of Albert Fletcher. *Cleveland Press Collection, CSU Michael Schwartz Library, Special Collections.*

On that warm April morning, workers arrived to complete a routine job. They were commissioned to tear down a dilapidated house at 6304 Ellen Avenue, which stood in a quiet neighborhood crowded with slowly aging houses. As the crew crashed into the first wall of the small house, the bulldozer came to an abrupt stop. The driver had spotted what looked like dollar bills floating in the dust particles. And his eyes were not playing tricks on him that day.

As the crew continued to bulldoze the house, more money, in denominations of twenties, fifties and hundred-dollar bills fell right out of the walls. The neighborhood kids, fascinated with the dismantling project, soon noticed the bills as well. Several of the youngsters grabbed a few handfuls and happily made their way to Lawson's to buy a real treasure—all the candy one could eat. Construction workers stuffed buckets full of cash and loaded the pay dirt into their pickups.

The "money house" once belonged to a recluse named Albert Fletcher. "Fletch" passed away in 1964, leaving his residence and several of his rental properties to his aging sister. The sister could not tend to the inheritance. As time went by, the properties were vacated, and eventually the family agreed that the Ellen Avenue property, one of the rentals, should be torn down.

However, this was not the first time that Fletch had sent "pennies from heaven." Shortly after the hermit's death ten years earlier, neighbors had descended on the West Sixty-fifth Street residence of the deceased. Rumors spread that the house had upward of $200,000 hidden in its two stories. The frenzy was heightened when Fletch's handyman, William Rutledge, was apprehended by the FBI in Texas. Apparently, the worker had stayed in the house while Albert spent his last month in the hospital. Authorities recovered $12,000 from the former employee. They believed he had stashed or spent thousands more. With this news in circulation, people eagerly helped in the cleaning-out process of the property.

What is known about Albert F. Fletcher, a quiet recluse of the area, comes from his nephew and a few neighborhood onlookers.

Albert was born in 1890. Not much is known of his growing-up years in Cleveland, other than that he was an extremely smart lad. During World War I, it appears that Albert was drafted; he served one year and received an honorable discharge due to health issues. He returned to pursue an education in electrical engineering from Case Institute of Technology. Later, he became head of the Ohio Electric Works in Cleveland. Over the course of his life, he acquired five houses, all within a few blocks of one another,

A man with a shovel walking toward the Albert Fletcher site. Note the wording on his jacket. *Cleveland Press Collection, CSU Michael Schwartz Library, Special Collections.*

and began renting out four of the houses at "high rental fees." However, it seems Fletch acquired much more than just property.

Upon his death, the inside of his residence displayed a lifetime of hoarding. Every room was knee deep in papers, bottles and various other household items. Among the piles, workers found record books of vast sums of money with no record of official bank deposits. Seven dump trucks were needed to clear all the items from the house.

Fletch never married or owned a car, according to his nephew. He was never known to buy anything, and rumors circulated that he sustained himself on a diet of watermelon. He mainly kept to himself, except when neighborhood kids would stop by the back door. Kindly, Fletch would give the kids slices of watermelon. Perhaps his mysterious lifestyle added to the treasure hunts of 1964 and '79.

It is believed that between $80,000 and $100,000 was found in the 1979 rush. Albert's nephew took no action to recover or claim the money. He told news reporters, "I'm out of the picture. It's none of my business." The nephew's mother, Albert's sister, would have been the heir. She was ninety-one at the time and in grave health. FBI and Secret Service agents showed up on the scene and deemed no crime was committed. Thus, no action was made to stop the money seekers during the following few days.

Occasionally, someone in Cleveland will recall the day of the "money house." Archived news footage can be found on the newnet5 online video vault section.

BONDS AND BONES, CLEVELAND

Most of the people in the building avoided him. George was not the friendliest guy in the neighborhood. So when he disappeared in 1874, no one really cared. In fact, the only reason anyone reported him missing was for fear of a rotting corpse on the premises. When police entered the building, they did not find a dead body. Peculiarly, they found a half-eaten meal at the table and George's shoes and coat by the door. It was as though the ninety-one-year-old hermit had vanished.

Nearly thirty-five years later, the old Ohio City Inn at 2811 Detroit Avenue had an appointment with the wrecking ball. W.C. Burns, owner, had decided to tear down the ancient eyesore. Burns hired a local fellow by the name of B.W. Hollinsworth for the job. Hollinsworth was permitted

to enter the building and acquire anything inside as partial compensation for his work.

Soon, it was time to start the demolition. Hollinsworth worked first at gutting the place. As the contractor tore down the walls in one of the back apartments, he was surprised to find a fireplace completely bricked in. While pulling out the loosened bricks from the hearth, Hollinsworth made a grisly discovery. In the reopened hearth, he found a pile of blackened bones scattered about.

Authorities soon arrived on the scene. Initially, the coroner determined the bones to be those of a woman. Yet after some thought, they realized the bones most likely belonged to the missing George C. Moran, past tenant. Robbery and murder were suspected.

A few days later, Hollinsworth returned to the task at hand. As he quickly attempted to finish work on the fireplace, another item of interest was found. This time, a metal box was pulled from a hiding place inside the hearth.

Rusted and locked up tight, the metal box was taken to the Union Savings and Trust Company, where it was opened by professionals. Inside was $116,740 worth of Erie Railroad bonds and $575 worth of gold coins. After a few heated words, Hollinsworth and Burns agreed to split the coins. The bonds, however, were to be held at the trust company for the next five years while a search was made for heirs. If none came forward, then Hollinsworth would be allotted the value of the bonds.

The little that was known about Moran pointed to the fact that he was in the habit of stashing money in his apartment. For thirty years, and making a pretty penny, Moran ran the Turnpike Tavern. Moran, a lifelong bachelor, was not a spender, although he apparently invested in the Erie Railroad Company. He eventually retired to the Ohio City Inn, which was not the most luxurious of places in Cleveland to live at the time. Most likely, the hermit kept all his money in the apartment and was robbed and then murdered for it.

As the story hit the newsstands, claimants by the hundreds came forth. It seemed many people in the United States were related to George. Long-lost cousins as far away as Ireland, Moran's home country, claimed to be heirs to the treasure. Eventually, the money was divided among several family members. The contractor received one third, approximately $38,000, of the treasure. Not bad for a day's work in 1907.

A Treasured Romance, Toledo

Greene Woods spent most of his days traveling. As a traveling salesman, he made a decent living. Because he was single and owned a profitable business, Greene often treated himself to luxurious inns and hotels on business trips to the city. In early 1888, the guest was relaxing in room forty-five of the exquisite Boody House hotel in Toledo. As he absent-mindedly ran his hand along the upholstery of his chair, he felt an odd piece. Pulling his hand from behind the cushion, the guest realized he held a diamond ring of great value in his hands. However, the ring's monetary worth would be no match for the treasure he would find a few days later.

Although it was a surprise to find the ring, it was not surprising that a guest who could afford such an item stayed in this hotel. The Boody House, built in 1870, was one of northeast Ohio's most magnificent lodgings. Boasting 150 luxurious suites, seven billiards tables, a bar and a huge dining room, the Boody House was the classiest place to stay in all of Toledo. Even President

The Boody House of Toledo. *From Library of Congress Digital Collection.*

Ulysses S. Grant had a favorite room in the building. So it was no surprise to Greene Woods when he noted the probable worth of the diamond ring.

Greene began to wonder how the ring was lost in the first place. Maybe someone hid the small treasure. Most likely, he deduced, the owner of the jewelry had been mindlessly playing with the upholstery. Being a thoughtful and kind man, Greene initiated a hunt for the owner.

First, Greene inquired at the office. The clerks assured him that no one had reported a lost ring. Returning to his room, Greene began to look for clues in the suite. After all, the owner had most likely stayed in this very room. A few minutes later, the amateur detective noticed something on the frame of the mirror. There, scratched into the surface, were the initials "M.C.F" and the words "September 16." Could this be possible? Was M.C.F the owner?

Greene returned to the office, where he asked to see the register for the previous September. Somewhat discouragingly, he found no match. Still not completely deterred, Greene asked for the register for September 1887. There, in pretty handwriting, Greene found the name May C. Fowler of Madison, Wisconsin.

A few days later, Greene was called for business in none other than Madison, Wisconsin. His first item of business, however, was to locate May Fowler. Using the city directory, Greene found several Fowlers listed. One Russell Fowler was listed as a lawyer. Based on this information, Greene decided to call on the Russell Fowler residence first, as lawyers were often quite wealthy—wealthy enough to afford a ring like the one he carried in his pocket.

Upon arrival at the residence, Greene inquired after May Fowler. The maid led Greene to the parlor, where Miss May and her father sat reading the newspaper. After a brief introduction, Greene asked Miss Fowler if she had ever been to Toledo. She ascertained that she had been to Toledo and stayed in a grand hotel, although she could not remember the name. Greene then asked if May had ever lost a ring, to which she responded in the affirmative.

When Mr. Fowler began to stir a bit over all the questions, Greene produced the ring. Quickly, as Russell was looking on suspiciously, Greene told the story of how he had found the ring, the initials and the address. The Fowlers were so impressed with the story and the kindness of a stranger, they asked Greene to stay.

After a wonderful evening of dining and conversing with the family, it was time to call it a night. Mr. Fowler insisted that Greene return again for a visit whenever he was in the vicinity.

A few weeks later, Greene returned to Madison and dropped by for another visit with the Fowlers. His visits continued throughout the year as Greene found many reasons to work in Madison.

On August 19, 1888, the *Toledo Blade* retold the story of Greene Woods and his found treasure. And on the very date the story was printed, M.C.F. became M.C.W. Both Greene and May had found the best treasure of all.

THE MONEY TREE, COSHOCTON

Money does not grow on trees, but apparently it might grow in them. Such is the tale of the old sugar tree stump on Jacob Stillbaur's farm.

In 1905, on a Monday morning in early spring, Jacob set to the task of completing chores around the mid-sized farm in Keene. It would soon be planting time, and he wanted to cross a few miscellaneous items off his to-do list. One in particular was the burning of some old stumps out in the backfields. He had put the task off for some time now, as he knew he would have to check and recheck the dead trees over the next few days once he lit them on fire.

On Tuesday morning, he went to inspect the trees. Most of the trees were piles of ash now. Strangely, though, one fire was still active. From the center of the old sugar tree, smoke wafted out. An odd metallic odor emanated from inside. As Jacob came in for a closer look, he was able to see down into the hollowed-out stump. There in the center of the tree was a mass of half-melted silver and gold coins. As the coins melted, the metal oozed out of the bottom of the tree near the roots.

Jacob ran for a bucket to collect the liquid gold. By day's end, the poor farmer was $3,000 richer. The coins were believed to have been hidden by an early pioneer family. It seems hard work really does pay off.

Chapter 9

LAWS OF THE LAND

TREASURE-TROVE LAWS

A treasure-trove is defined by federal law as the "discovery and/or recovery of money, coin, jewelry, or gold or silver bullion buried or lost by an unknown owner or owners." To be a lost trove, the recovered treasure must be old enough that the original owner is unable, by death, to claim it.

Over the last century, as troves have been found, disputes have erupted all over the United States. States have adopted their own rules and regulations for this process. As for Ohio and a handful of other states, lawmakers have chosen to revert back to the old common law. Basically, this law states that finders are keepers, as long as the original owner is no longer living. If heirs to the treasure can prove themselves, they will receive a partial sum of the monetary worth. If the owner of the property finds the treasure, he/she is entitled to the total amount. If a finder is hired to work on the property, the treasure shall be split between finder and owner.

In most cases, however, the law tends to be confusing and messy. The rule of thumb in Ohio, however, seems to be that finders are keepers.

In the case of state or federally owned lands, the law differs. In 1979, the Archaeological Resources Protection Act (ARPA) was passed in order to preserve artifacts of historical significance. This law states that items may not be removed from public or Indian lands. The crime is punishable by up to $100,000 in fines and ninety days' imprisonment.

A ring found in the lake by diver Jack Wade between the years 1972 and 1992. *Photo courtesy of Jack Wade.*

Likewise, treasure found under water has its own set of regulations. In 1953, Congress passed the Submerged Land Acts, which gave ownership of underwater land to the state. The underwater land would eventually be subject to the ARPA of 1979. Thus, if a sunken ship is found, it belongs to the state as long as the ship has been deemed abandoned by the original owner. The law was further strengthened by the Abandoned Ship Act of 1987. Accordingly, Ohio Statute 1506 states that "any rule adopted under this division shall describe the area included in the preserve so designated and the abandoned property or features of archaeological, historical, recreational, ecological, geological, environmental, educational, scenic, or scientific value found in the preserve."

The law has led to debates among divers and historians. Divers who find items within the preserve are expected to turn it in to the state. However, many items, including antiquated coins and jewelry, found by the diving hobbyists were retrieved miles away from the official wreck boundaries.

Regardless of whether you find treasure in the water, in the ground or in a secret hiding place, it is subject to many laws.

Chapter 10

A MODERN-DAY TALE

In 2006, Amanda Reece of Cleveland was excited for the renovations planned. One of the many reasons she loved the house was its old-time feel. She wanted to preserve that feeling, while upgrading some of the fixtures and walls that had begun to deteriorate over the last eighty-three years. And she knew just the man for the job: Bob Kitts.

Bob and Amanda had been friends since high school. They had kept in contact over the years, so Amanda was aware of his handyman services. She trusted Bob to renovate the insides of her new home, and Bob was excited to do just that.

One day, as Bob was tearing out a wall in the bathroom, he spotted something odd peeking between the two walls. As Kitts pulled the mirror loose, he noticed two green metal boxes suspended from a wire between the walls. He pulled the boxes free and found an envelope marked "P. Dunne News Agency." Inside the envelope was a fifty-dollar bill. Bob called Amanda at once.

When Amanda arrived home, the two excitedly pulled more money from the walls. Some of the bills were rare collectors' items, including $500 and $1,000 bills. By today's value, the treasure was worth $182,000.

At first, the friends talked of how they would split the cache. However, vicious months of fighting and legal litigations soon ensued. Likewise, with the media publicity, the courts were alerted of twenty-one true heirs to the Dunne stash.

By the end of the dispute in 2008, the money was nearly depleted. With court costs and distribution to the twenty-one heirs, only $23,000 remained. The two ex-friends were ordered to split the cash.

Chapter 11

TREASURING TALES

Happiness is your own treasure because it lies within you.
—Prem Rawat

It's 5:00 a.m., and I am buried in old newspaper clippings. I am being taunted by a blank Word document with a blinking, annoying cursor. I have to write the next chapter. My dream is to find a story on a treasure so big and undeniably real that my readers will be left in awe. Yet that story is never found in my archive collection.

Instead, sighing, I wade through treasure articles on pioneer stashes, murder mysteries and missing family heirlooms. Stories centered on missing money or valuables. Where are the buried chests full of gold? They are certainly not in this collection.

And then it hits me—the reason I enjoy local treasure legends in the first place. For in the mass of articles, I had already found the real treasure. The people who made the news of olden days, no matter how strange or peculiar, were very much like the people of today. I had connected with these past Ohioans upon first reading about them. Their struggles, their kindness and even their sins encompass human nature throughout time. The treasure, thus, is in knowing these people, their lives and their legacies.

As I go about writing my book, I am again amazed with the tales. A family struggling to make it in the harsh wilderness go to any lengths to protect their future. Soldiers, under impending attack, risk their lives to save valuables that in turn could save the country. A hermit, filled with loneliness, hides his life's savings in a rusted bucket because he has no use for it in his solitary existence.

The author's daughter and nephews discussing the whereabouts of Blackbeard's treasure. *Author's collection.*

With each story, I get closer to sharing the treasures with my future readers. I hope that they, too, will find the real treasure in the words, for it is not the reported treasure-trove of gold that endears us but rather the tales of the people who hid it in the first place.

BIBLIOGRAPHY

Akron Beacon Journal

Balint, Ed. "The Long Legend of Minerva Gold." Ancient Lost Treasures Forums. http://ancientlosttreasures.yuku.com/topic/3811#.UiOZHGXD_ug (accessed September 1, 2013).

Blue, Herbert Tenney Orren. *History of Stark County, Ohio, From the Age of Prehistoric Man to the Present Day*. Chicago: Clarke, 1928.

Brewer, Mary Jane. "What's Brewing." Cleveland.com blog. http://blog.cleveland.com (accessed July 1, 2013).

Butterfield, Consul Willshire. *History of the Girtys: Being a Concise Account of the Girty Brothers, Thomas, Simon, James and George, and of Their Half-Brother, John Turner.* N.p., 1890.

Canton Repository

Chicago Tribune

Conneaut New Herald

"Daniel Andrew Shafer (1846–1924)." Find A Grave Memorial. http://www.findagrave.com/cgi-bin/fg.cgi?page=gr&GRid=101910085 (accessed September 1, 2013).

Dixon, Arthur. "The Giant of the Hills: Martin Van Buren Bates." TNGenWeb Project, Inc. http://www.tngenweb.org/scott/fnb_v7n2_martin_van_buren_bates.htm (accessed September 1, 2013).

Gerrick, David J. *Ohio's Ghostly Greats*. Lorain, OH: Dayton Press, 1982.

"A History of Central Banking in the United States." Federal Reserve Bank of Minneapolis. http://www.minneapolisfed.org/community_education/student/centralbankhistory/bank.cfm (accessed September 1, 2013).

Hurley, Gerald. "Buried Treasure Tale in America." *Western Folklore* 10, no. 3 (1951): 197–216.

Jackson Citizen (Michigan)

Korenko, Leslie. *Kelley's Island, 1866–1871: The Lodge, Suffrage & Baseball*. Kelley's Island, OH: Wine Press, 2012.

Kraynek, Sharon Lee DeWitt. *The Captain and Anna: A Brief History of Giants of Seville, Ohio.* Chippewa Lake, OH: Medina Books, 2004.

"The Law of Treasure-Trove." DeConcini McDonald Yetwin & Lacy, PC. http://www.deconcinimcdonald.com/2008/11/the-law-of-treasure-trove-or-who-gets-the-found-money (accessed September 1, 2013).

Lewis, Margaret. "Lost Treasure of the Steamship *G.P. Griffith.*" *Lost Treasure,* June 1, 2009.

Lloyd, James T. *Lloyd's Steamboat Directory.* Philadelphia: J.T. Lloyd, 1856.

Marx, Robert. *Buried Treasure You Can Find.* Dallas, TX: Ram Books, 1993.

McLeod, Patrick. *Marquette and Bessemer 2.* http://www.marquetteandbessemer2.com (accessed September 1, 2013).

Mihm, Stephen. *A Nation of Counterfeiters: Capitalists, Con Men and the Making of the United States.* Cambridge, MA: Harvard University Press, 2007.

Moore, Todd. *Dillinger.* Allston, MA: Primal Pub., 1990.

Mullen, Patrick. "The Folk Idea of Unlimited Good in American Buried Treasure Legends." *Journal of the Folklore Institute* 15, no. 3 (1978): 209–20.

New York Times

ODNR. "Pymatuning State Park." ODNR Division of State Parks. http://parks.ohiodnr.gov/pymatuning (accessed June 1, 2013).

Paine, Ralph. *The Book of Buried Treasure.* New York: W. Heinemann, 1911.

Perrin, William Henry. *History of Stark County, with an Outline Sketch of Ohio.* Chicago: Baskin & Battey, 1881.

Plain Dealer (Cleveland, OH)

Price, Mark. "Requiem for a Diva of Mystery." History-Ohio. http://www.ohio.com/lifestyle/history/requiem-for-a-diva-of-mystery-1.202340 (accessed September 1, 2013).

Remick, Teddy. "Beach Bonanzas from Great Lakes Wrecks." *Lost Treasure,* December 1, 1971.

———. "Lost Gold Hoard in Ohio." *Lost Treasure,* December 1, 1969.

Scarbrough, Byron. *The Giants of Seville.* N.p.: Byron Scarbrough, 2006.

Star Beacon Journal (Ashtabula, OH)

"Timeline of John Dillinger's Trail of Crime." Northwestern. www.thenorthwestern.com/article (accessed July 1, 2013).

Toledo Blade

Trickey, Eric. "Found and Lost." Article Archives, Cleveland Magazine. http://www.clevelandmagazine.com.

Turzillo (Paxton), Jane Ann. "The Counterfeiter." *Dixie Times Picayune,* October 19, 1975.

"Video Vault: Demolition of Cleveland 'Money House' Sets Off 1979 Free-for-All." Newsnet5.com. http://www.newsnet5.com/dpp/news/news_archives/video-vault-demolition-of-cleveland-money-house-sets-off-1979-free-for-all (accessed September 1, 2013).

Zurcher, Neil. *Strange Tales from Ohio: True Stories of Remarkable People, Places, and Events in Ohio History.* Cleveland, OH: Gray and Co., 2005.

INDEX

Shenango River 88
Shunk, Ohio 29
Simon Girty 31, 32, 34
Stark County 9
Stevenson, Robert Louis 13
Stillbaur, Jacob 116
submerged land 118
Sullivan, Kate and Johanna 95
Swan, Anna 70

T

Taylor, Bill 41
Toledo, Ohio 82, 93, 95, 114, 115, 116
Treasure Island 13
Turkeyfoot Creek 29, 30
Turner, John 32

V

Viller, Burl 47

W

Wade, Al 96
Wade, Ben 96
War of 1812 26
Warren, Ohio 47
Wayne, Anthony 28, 33
Weiss, Albert 77
Wilkinson, William 51
Willowick Beach 82
Woods, Greene 114

Y

Yellow Creek 43

ABOUT THE AUTHOR

 Wendy Koile is a lifelong resident of Ohio. In 2012, she published her first book, *Geneva on the Lake: A History of Ohio's First Summer Resort.* When not writing or traveling, Koile teaches at Zane State College.